IMAGES
of America

CUTTYHUNK
AND THE
ELIZABETH ISLANDS

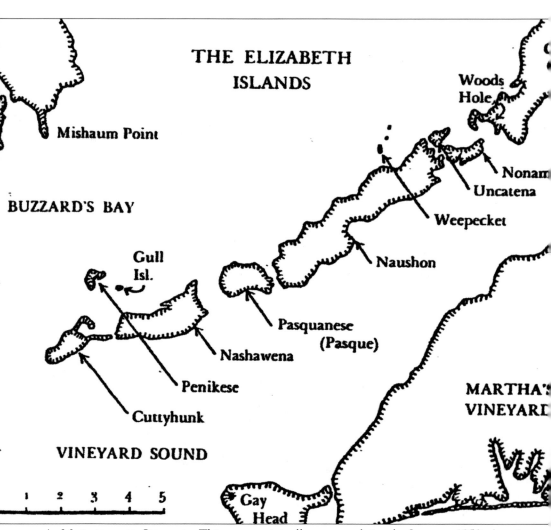

THE ELIZABETH
ISLANDS

Woods
Hole

Mishaum Point

Nonam

Uncatena

BUZZARD'S BAY

Weepecket

Naushon

Gull
Isl.

Pasquanese
(Pasque)

Nashawena

Penikese

MARTHA'S
VINEYARD

Cuttyhunk

VINEYARD SOUND

1 2 3 4 5

Gay
Head

A MAP OF THE ISLANDS. This map originally appeared in the January 1950 *American Neptune*.

The islands of Buzzards Bay are these;
Cuttyhunk, Penikese,
Nashawena, Pasquanese,
Naushon, Weepecket,
Uncatena and Nonamesset.

IMAGES
of America

CUTTYHUNK
AND THE
ELIZABETH ISLANDS

Cuttyhunk Historical Society

ARCADIA
PUBLISHING

Copyright © 2002 by Cuttyhunk Historical Society
ISBN 978-0-7385-0980-8

Published by Arcadia Publishing
Charleston, South Carolina

Printed in the United States of America

Library of Congress Catalog Card Number: 2001096957

For all general information contact Arcadia Publishing at:
Telephone 843-853-2070
Fax 843-853-0044
E-mail sales@arcadiapublishing.com
For customer service and orders:
Toll-Free 1-888-313-2665

Visit us on the Internet at www.arcadiapublishing.com

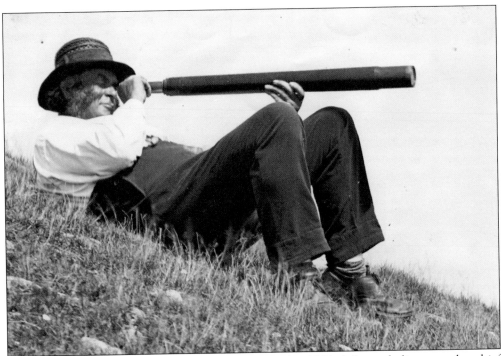

CAPT. BENJAMIN CHURCH, PILOT, C. 1870S. In the 1800s (when whaling was the chief business of the port of New Bedford and clipper ships were involved with the China and West India trade), pilots were needed to usher vessels through Buzzards Bay. Cuttyhunk's Lookout Hill, at 168 feet, gave the few pilots with a "long glass," such as Benjamin Church, early notice of an approaching sail. They guided the vessels past the many unmarked ledges of Buzzards Bay. Eleven ships were once taken into New Bedford in a single day by Cuttyhunk pilots.

CONTENTS

ACKNOWLEDGMENTS

The purpose of the Cuttyhunk Historical Society is to preserve the traditions, records, and history of the Elizabeth Islands for the benefit of present and future generations.

The process of creating this book has given us an even greater appreciation for the Elizabeth Islands and the lasting legacy of the people who have lived and worked on them. It has also been a privilege to collaborate with so many who share our love and respect for the islands' varied history.

We are appreciative of the generosity of the following people, who were invaluable for their historical information, images, resources, and editing: Mary Jean Blasdale, Janet Bosworth, Elaine Doran, Jennifer Gaines, Kitsy Garfield, Wye Garfield, Thomas Gregg, Oriel Ponzecchi, Carolyn Powers, Betty Stevens, George Stetson, Olive Swanson, Charles Tilton Jr., David Twichell Jr., Nic Van Dongen, Alan Wilder, and Jan Wilder. A special thank-you goes to Holly Leon for her contributions to the chapter on Naushon, Pasque, and Nashawena and to Tom Buckley for his help on the Penikese chapter.

We extend our gratitude to all those friends and Cuttyhunk Historical Society members who, over the years, have contributed artifacts, information, postcards, photographs, and (recently) words of encouragement. A very special thank-you goes to our families for their love, humor, and support.

—Ethel R. Twichell and Shelly L. Merriam

The town seal was designed by Arthur Motta Jr.

6

INTRODUCTION

The Elizabeth Islands lie in a 14-mile string between Buzzards Bay and Vineyard Sound, running northeast to southwest from Woods Hole on Cape Cod. Naushon, Pasque, and Nashawena lie at the beginning of the chain. They are privately owned by members of the Forbes family. Next in line is Cuttyhunk, the town seat of Gosnold, and last Penikese, where an alternative school for troubled boys is now located. The early settlers all shared the same hardships of island existence. Over the years, however, those who have chosen to live there have given each island its own history and character.

As far as is known, the local tribes of the Wampanoags made few permanent settlements on the Elizabeth Islands, using them mostly for hunting, fishing, and gardening during the summer months. Occasional arrow points or stone implements that surface on the islands remind us of their presence, as do the island names. The arrival in 1602 of the English explorer Bartholomew Gosnold marked the beginning of major changes for the islands and the Wampanoags. Although many European explorers and fishermen had already traded with the Native Americans in the waters off New England, Gosnold was the first to attempt establishing a trading post. He and his men built a small encampment on an island in the West End Pond at Cuttyhunk. Their meetings with the Wampanoags were generally friendly, but when his men learned they would be left behind without sufficient provisions, the settlement was abandoned after only a few weeks, and Gosnold returned home.

Upon Gosnold's return to England, the islands came under the jurisdiction of the British Crown. In 1641, Thomas Mayhew (a Watertown merchant) was given the "right to plant on the Elizabeth Isles." All the islands had previously been claimed by the Wampanoag sachem, who in 1658 gave the deed of ownership to Mayhew. In 1685, all the islands were transferred to Martha's Vineyard Manor and were later assigned to the township of Chilmark. In 1864, residents petitioned the General Court of Massachusetts and won the right to be their own entity as the town of Gosnold.

NAUSHON. During those early years, all the islands passed through many changes of ownership. In 1682, Thomas Mayhew's grandson sold Naushon to Wait Winthrop, whose grandson in turn sold the island to James Bowdoin in 1730. By this time, the island had been timbered and there were small farms and large flocks of sheep. During the Revolution, Naushon farmers suffered severe hardships when British raiders made off with their sheep, cattle, and wool. A small fortification with a few cannons was erected at Tarpaulin Cove for protection but was destroyed by the more powerful British invaders. With the death of the last Bowdoin descendant in 1842, the island was purchased by William Swain and John Murray Forbes, whose descendants continue to summer in the beautiful homes preserved there.

PASQUE. Like Naushon, Pasque was heavily timbered. Little is known of life there under the ownership of the Mayhew family. However, records show that they did begin some missionary

work with the Native Americans who had begun to settle there. Like Naushon, it passed through several different owners, including Abraham and John Tucker (who built at least one dwelling for their caretakers) and Daniel Wilcox. By 1790, there were 21 people living on the island. A major change came in 1866, when the newly formed Pasque Island Corporation bought the island from Benjamin and Joseph Tucker and constructed the Pasque Island Club. Unlike the earlier Cuttyhunk Fishing Club, it welcomed women. It closed in 1923 and remained in the hands of James Crosby Brown, its major stockholder. He sold it to J. Malcolm Forbes and William H. Forbes in 1939. Members of the Forbes family still own the island.

NASHAWENA. Peleg Sanford, Philip Smith, and Thomas Ward purchased Nashawena and Cuttyhunk from Thomas Mayhew in 1666, probably cutting the timber for a handsome profit. They in turn sold most of their shares to Peleg Slocum, a well-known Quaker from Dartmouth, who along with his descendants, operated a farm on Nashawena. In 1860, Capt. Edward Merrill, a wealthy whaling captain from New Bedford, bought the island as a retreat and continued to maintain the farm. He in turn sold it to Waldo and Edward Forbes in 1905. Of all the islands, Nashawena has best succeeded in retaining its agricultural character. Only two or three summer cottages dot the hillsides, and caretakers continue to maintain the farm.

CUTTYHUNK. The Slocums maintained their large holdings on Cuttyhunk for many years, but island families like the Tiltons, Allens, Veeders, and Bosworths built their own homes, maintained their own gardens, and earned a living from the sea as fishermen and pilots and in the U.S. Life-Saving Service. With the establishment of the Cuttyhunk Fishing Club in 1864, a regular ferry service brought visitors to the island from the mainland, and Cuttyhunk began an era of tourism. After the islands joined to become the township of Gosnold in 1864, Cuttyhunk emerged as the town seat because of its growing population. By 1891, it had its own school, a church, and a library. In 1909, William Wood, president of the American Woolen Company, built the first of two large homes, Avalon, followed in 1917 by Winter House. In 1923, he bought out the Cuttyhunk Fishing Club and all its holdings. Alone among the islands, Cuttyhunk hosts growing numbers of summer residents and visitors.

PENIKESE. Finally, Penikese adds its story. It, too, passed through several owners, was timbered, and used to pasture sheep. In addition, two or three early families earned a living by fishing, piloting, and wrecking (salvaging). In 1865, a small menhaden-oil factory was established there, followed two years later by its sale to John Anderson, a wealthy New York tobacco merchant. In 1873, he funded the Anderson School of Natural History, with Louis Agassiz as director. The school closed soon after Agassiz's untimely death, and the Homer family bought the island and farmed it. Then, in 1905, the State of Massachusetts opened a leprosarium there, causing a furor on the other islands. The colony, under Dr. Frank Parker and his wife, continued until 1921, when the surviving lepers were transferred to a colony in Louisiana. After some years of lying vacant, the island is now the site of the Penikese Island School, which offers delinquent boys alternative schooling and counseling.

And so, the islands have changed over the years, each with its own problems, its own loyalties, and its own personality. For those who have chosen to live there, their beauty and remoteness have been a source of challenge and affection.

One

EARLY HISTORY

European explorers had already met and traded with Native Americans well before 1602, when the Englishman Bartholomew Gosnold explored the waters around Cape Cod, Martha's Vineyard, and the Elizabeth Islands. Gosnold's encampment on an island in Cuttyhunk's West End Pond was the first attempt at a permanent settlement in North America. While this fort was occupied for only a few weeks, journals kept by Gabriel Archer (a lawyer) and John Brereton (a cleric), who traveled with him, give a fine record of what they saw during that voyage. They describe prominent landmarks, the local flora and fauna, and the native people they encountered. Brereton writes of one meeting this way:

> These people, as they are exceeding courteous, gentle of disposition, and well-conditioned, excelling all others that we have scene; so for shape of body and lovely favour, I think they excell all the people of America; of stature much higher than we; of complexion or colour, much like a darke Olive; their eibrowes and haire blacke, which they wear long, tied up behind in knots, whereon they pricke feathers of fowles in a fashion of a crownet [coronet].

These journals picture a newly discovered world, rich in resources of wildlife and timber and inhabited by a handsome people who lived in peace with their surroundings. Gosnold returned to England with a valuable cargo of cedar and sassafras. He sailed to America once more, settling in Jamestown, Virginia, where he died in 1607.

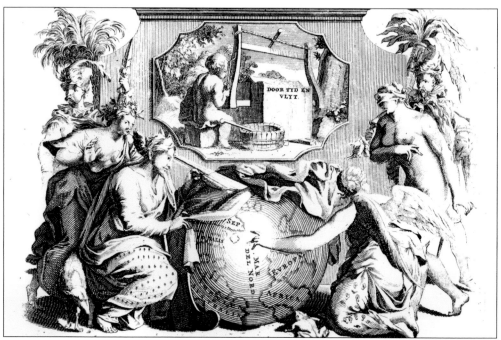

EXPLORING THE NEW WORLD. This illustration appeared in a 1706 publication of Gabriel Archer's journal, translated into Old Dutch. Archer was aboard the *Concord* with Gosnold in 1602. In the image, a winged angel points the way to the New World for a blindfolded woman. Another woman, probably Wisdom, pulls a drapery off a globe while yet another woman and two elaborately dressed guards stand by. The words on the cartouche may be translated, "through time and work." (Engraving by Pieter Vander Aa, *c.* 1706.)

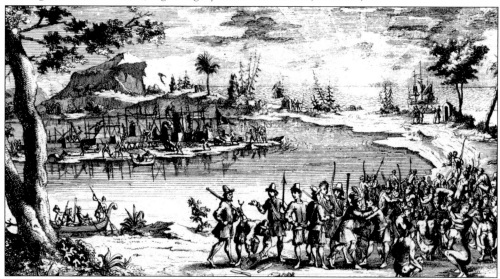

GOSNOLD'S SETTLEMENT ON ELIZABETH'S ISLE. Gosnold gave the name Elizabeth's Isle to what is now Cuttyhunk. This representation of Gosnold's encampment there appeared in the same Old Dutch version of Archer's journal. While the meeting of Gosnold's men and the Wampanoags seems friendly, Archer's journal cites a few skirmishes between the two groups. (Engraving by Pieter Vander Aa, *c.* 1706.)

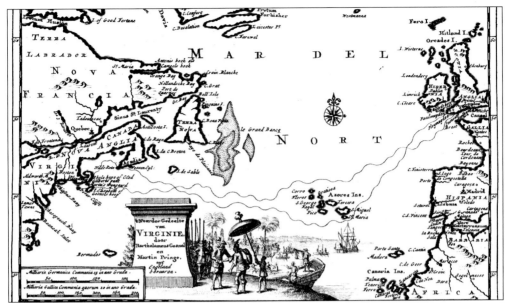

GOSNOLD'S VOYAGE. This map appeared in the same 1706 Old Dutch reprint of Archer's journal and uses a curious mixture of languages for place names. In Gosnold's time, New England would have been known as Northern Virginia. The palm trees and huge umbrella add exotic touches to Gosnold's meeting with the Wampanoags. (Engraving by Pieter Vander Aa, c. 1706.)

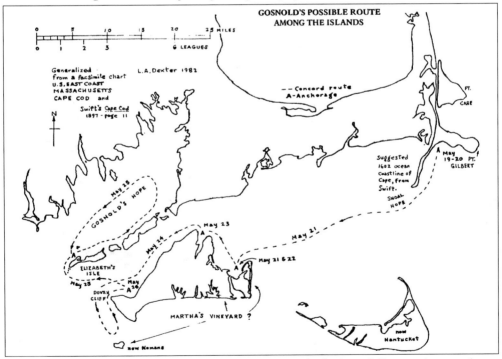

GOSNOLD'S POSSIBLE ROUTE AMONG THE ISLANDS. Archer's and Brereton's journals are the main source of information on Gosnold's explorations. As navigation instruments were primitive, it is difficult to assign the nomenclature in their journals to present localities. This map gives a reasonable interpretation of Gosnold's route. (Courtesy Lincoln A. Dexter.)

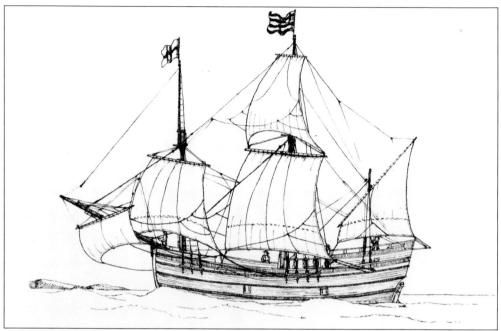

THE BARK CONCORD. The estimated specifications for Gosnold's ship are as follows: 39 feet on the keel, 49 feet at the waterline, a 17.5-foot beam, and a rating of 50 tons. On March 26, 1602, the ship set sail from Falmouth, England, with two captains and 30 hands aboard. It made landfall on May 14, 1602, near Cape Neddick, Maine. (Sketch by William Baker; courtesy New Bedford Whaling Museum.)

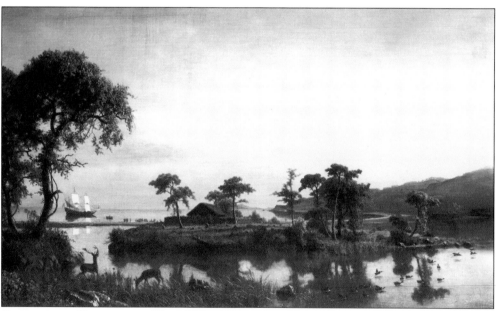

GOSNOLD AT CUTTYHUNK. This 1858 painting by Albert Bierstadt also gives a romantic interpretation of Gosnold's encampment at the West End Pond. The *Concord* lies quietly at anchor while Gosnold's men and the Wampanoags gather peacefully on the beach. (Courtesy New Bedford Whaling Museum.)

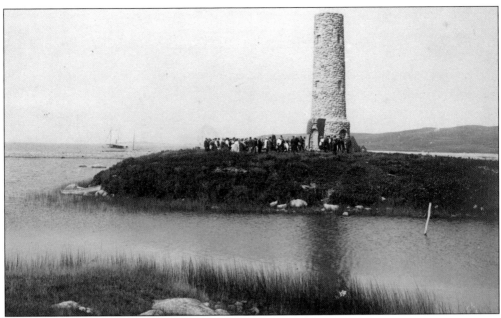

THE DEDICATION OF THE GOSNOLD MONUMENT. Members of the Old Dartmouth Historical Society initiated the building of the Gosnold Monument. It was begun in 1902, completed in 1903, and dedicated on September 1, 1903, before a large gathering of people from the New Bedford area and Cuttyhunk. The steamer *Gosnold,* which brought visitors from New Bedford, can be seen in the background. (Courtesy New Bedford Whaling Museum.)

TERCENTENARY MEMORIAL
TO
BARTHOLOMEW GOSNOLD
AND HIS COMPANIONS, WHO LANDED HERE
JUNE 4 (O.S. MAY 25) 1602
AND BUILT ON THIS ISLET THE FIRST ENGLISH HABITATION
ON THE COAST OF NEW ENGLAND.

~

CORNER STONE LAID JUNE 4, 1902
DEDICATED SEPT. 1 (O.S. AUG. 22) 1903
ANNIVERSARY OF GOSNOLD'S DEATH AT JAMESTOWN, VA.

THE DEDICATION PLAQUE. Workmen inscribed these words on a slate tablet on the tower. Constructed of native fieldstone, the ruggedly built monument is 18 feet in diameter at the bottom, 12 feet across at the top, and 60 feet tall. It has remained a familiar landmark over the years. The letters O.S. refer to the Old Style Julian calendar. Later, England adopted the New Style Gregorian calendar, which adds 10 days to dates given by Brereton and Archer.

13

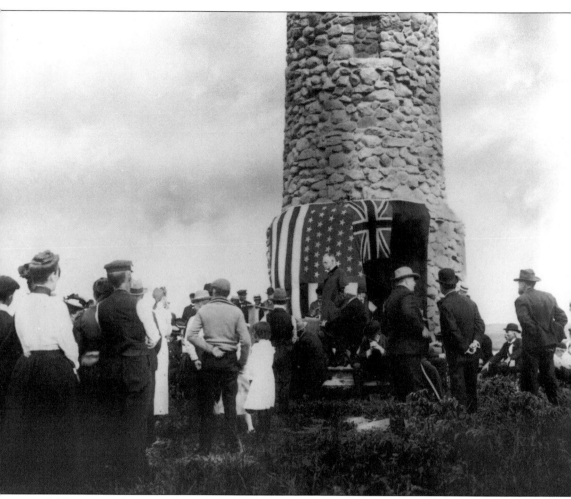

A HISTORIC MOMENT. At a given signal, two islanders—Frederick Slocum Allen and Myrtie Bosworth —tugged at the lines until the British and American flags covering the plaque fell away. As the ceremonies closed, the audience gave three cheers for the citizens of Cuttyhunk. The guests from New Bedford were then ferried out to waiting boats for their trip home.

Two

ABOUT TOWN

Originally, the village on Cuttyhunk was only a cluster of small houses, each family with its own small garden, a cow or two, and chickens. The men were farmers and fishermen. It must have been a closely knit community, as marriages between members of early island families were frequent.

The town of Gosnold became an official entity in 1864, when the Elizabeth Islands received permission to separate from Chilmark on Martha's Vineyard. At first, town meetings and elections were held on Naushon but were moved to Cuttyhunk in 1874. The village center began to grow with the building of the school in 1873, the church in 1881, a library in 1893, and the town hall in 1926.

The Cuttyhunk Fishing Club, founded in 1864 by a group of wealthy New York businessmen, brought island men new sources of employment as caretakers, chummers, and gardeners. When the club closed in 1921, William Wood, president of the American Woolen Company, bought out its large holdings. He built two substantial homes on the island, Avalon and Winter House.

By the 1880s, regular ferry service from New Bedford brought day-trippers from the mainland for shore dinners, and many island homes became boardinghouses. Tourism had begun. In the late 1920s, Cornelius Wood (William's son) invited friends to stay at Avalon, his late father's home. These friends eventually purchased other island homes from Wood, and most of these houses have remained with those families. The end of World War II brought further arrivals of summer residents and visitors and, with them, ever increasing changes in this small island community.

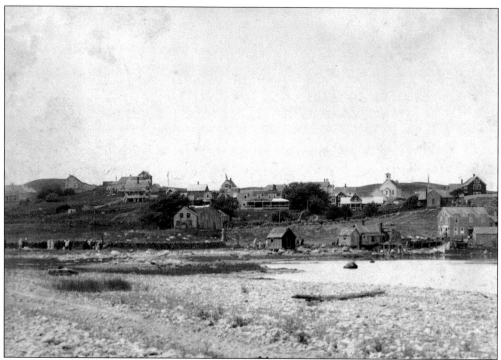

THE VILLAGE FROM THE LANDING, EARLY 1900S. Visitors can be seen walking up from the Landing (today the town dock), perhaps for lunch at the Allen House (middle) or the Bosworth House (upper right). Sunny weather would have brightened the otherwise spare landscape and simple village dwellings.

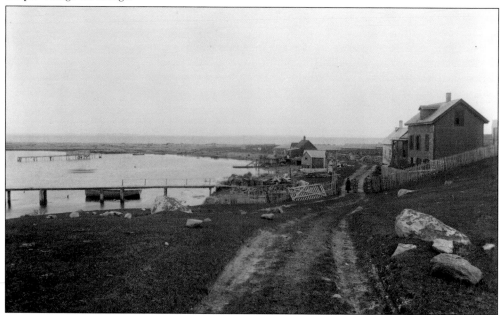

THE CORNELL COMPOUND, C. 1891. The Hurricane of 1938 swept these houses away. The spit of land behind them leads out to the Landing. The barren landscape bespeaks a life of hard work and few luxuries. (Courtesy New Bedford Whaling Museum.)

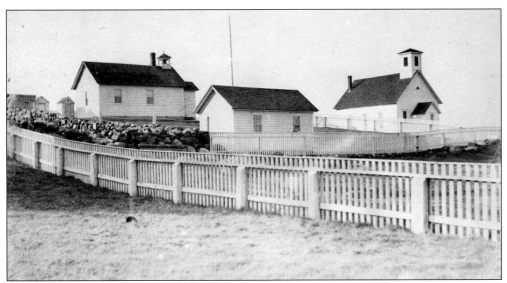

THE VILLAGE CENTER, C. 1904. Important town buildings cluster together on Tower Hill Road. The one-room school on the left, the small library in the middle, and the white church are still in use and, with some additions, appear much the same today. Picket fences and stone walls kept sheep out of the village.

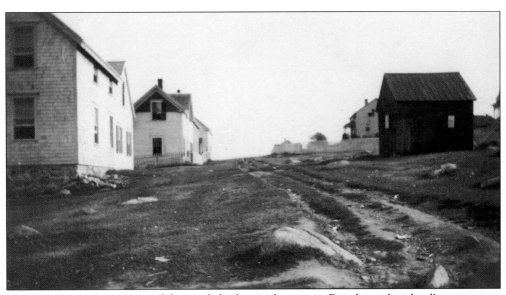

BROADWAY, C. 1890. A rutted dirt road climbs up what is now Broadway, the island's main street. To the right is the small building that housed the town's weights-and-measures scales and, on summer weekends, the Methodist minister. It was moved in 1893 and became the town library. To the upper left is the Keeney house, where Keeney descendants still live most of the year.

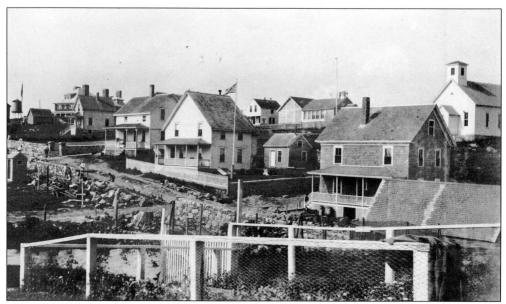

BROADWAY, 1919. Beginning in the 1870s, many of the houses along Broadway became boardinghouses during the summer months. Their architecture is strikingly similar, with pitched roofs and comfortable porches. The garden in the foreground is near the site of the current Island Market.

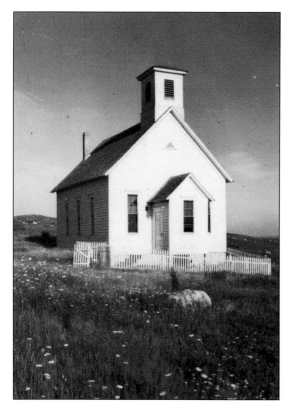

THE CUTTYHUNK UNION METHODIST CHURCH, C. 1904. The town built this church in 1881 after the Cuttyhunk Fishing Club gave the land. It is a simple building, with pressed-tin interior walls and plain wooden benches. A belfry and a pastor's study were added later. During the summer, the church provides Catholic mass, Episcopal and Methodist services, and Sunday school.

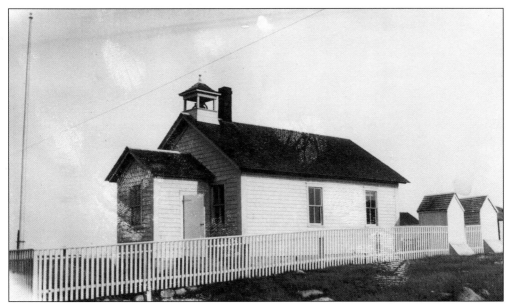

THE VILLAGE SCHOOL, C. 1905. Although it now has a playground, the one-room school (built in 1873) looks much the same today. In 1883, 18 students were enrolled in grades one through eight and the teacher received a salary of $252. As in the past, students must leave the island to attend high school on the mainland.

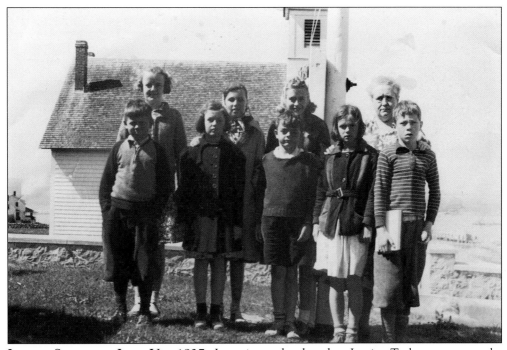

ISLAND STUDENTS LINE UP, 1937. Longtime schoolteacher Louise Taylor appears to be keeping a firm hand on one of her pupils. From left to right are the following: (front row) John Stubbs, Margaret Jenkins, Charles Tilton, Ethel Stubbs, and Charles Harrington; (back row) Doris Tilton, Joan Veeder, Eleanor Snow, and Louise Taylor (later Mrs. George Haskell).

THE TOWN LIBRARY, C. 1903. Over the years, the library has acquired several small additions, but a group of five or six patrons inside still seems like a crowd. The library is open twice a week in the summer and once a week in the winter.

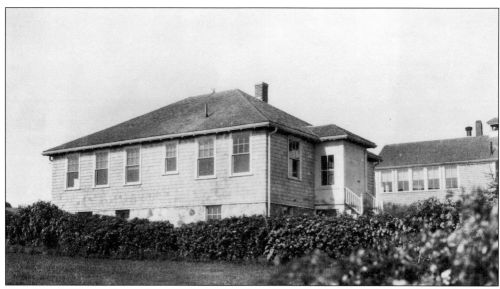

THE TOWN HALL. Erected in 1926, this building contains a meeting room with a stage, the selectmen's and town clerk's offices, and (in the basement) a single jail cell, now used for storage. Two culprits were detained there in the 1930s.

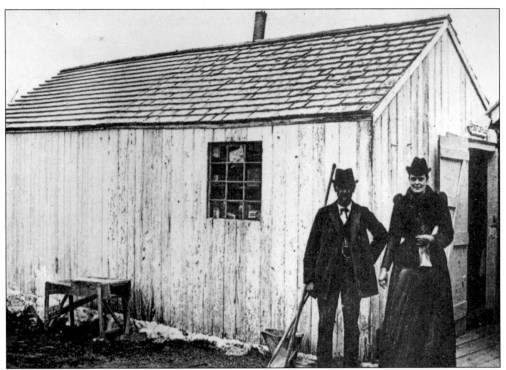

FREDERICK AND ANNETTE VEEDER, C. 1890. Both the Veeders served customers in this small post office, located beside their own house. The Veeders also ran a boardinghouse, often camping out in a tent in order to provide more rooms for visitors.

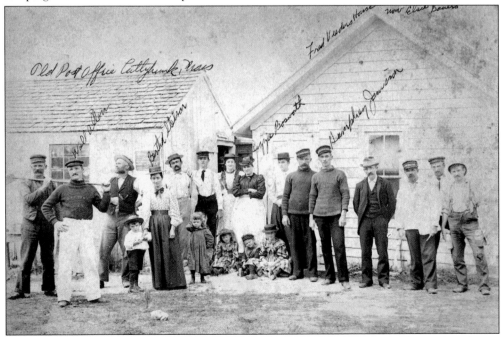

WAITING FOR THE MAIL, C. 1910. Picking up the mail was a time to gather and exchange island news. The men in visored caps are all members of the U.S. Life-Saving Service.

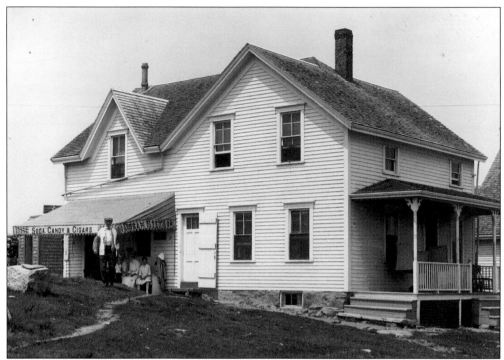

THE STORE, 1914. Customers enjoy a rest in front of the island's only market, managed by Oscar Stetson. For many years, the store was located across from the Cuttyhunk Historical Society but has moved several times as owners and managers have changed. (Courtesy New Bedford Whaling Museum.)

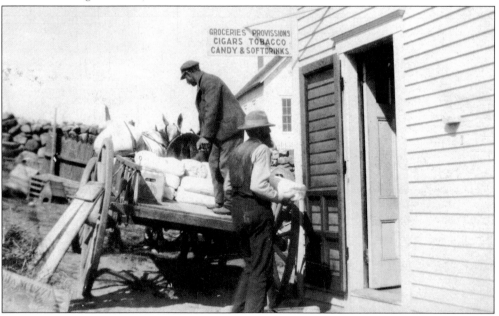

UNLOADING SUPPLIES, C. 1900. Two men carry what looks like a year's supply of flour into the store under a sign that advertises "provissions." Mule-drawn wagons used to be a familiar sight on the island.

LOOKING TOWARD CHURCH'S BEACH, 1934. A solitary car drives confidently down the middle of newly paved Bayview Drive. Islanders recall that the only two island cars once had a head-on collision. Jane Jones used to sell souvenir china decorated with Cuttyhunk scenes in the little house pictured here.

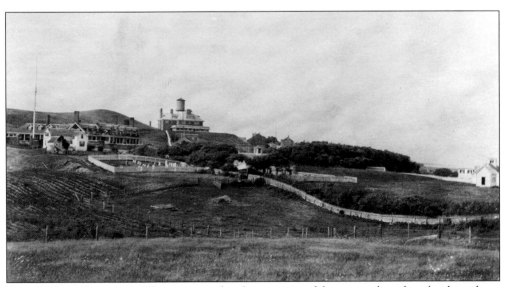

THE ISLAND CEMETERY. The cemetery has been a peaceful resting place for island residents since the mid-19th century, when the Cuttyhunk Fishing Club (right) donated the land. The club caretaker lived in the white house on the left. The picket fence used to extend across the entire island and was painted each summer.

THE VIEW FROM LOOKOUT HILL. These handsome walls were to lead to the house that William Wood intended for his son, William Jr. Before construction began, the young man died in an automobile accident, and the house was never built. The top of the road, now paved, is a

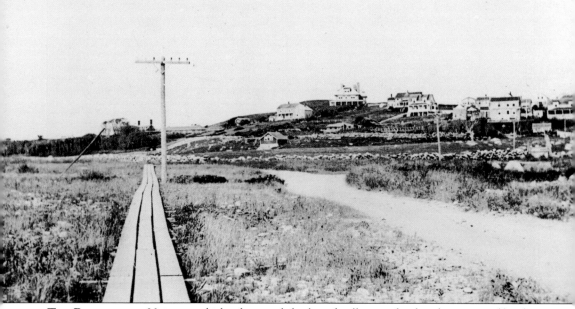

THE BOARDWALK. Visitors and islanders used the boardwalk over this low-lying spit of land to get to the village from the Landing (today the town dock). The Cornell Compound is on the

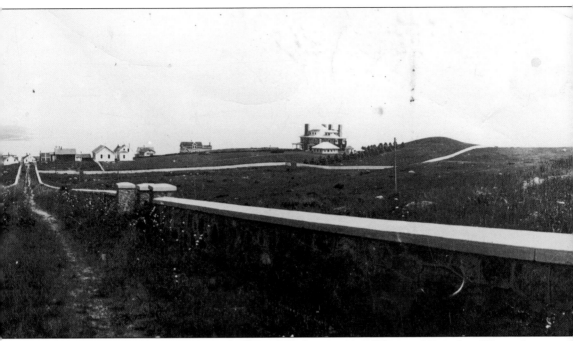

popular place to watch the sunset and offers a 360-degree view of Vineyard Sound and Buzzards Bay. (Postcard by Defender.)

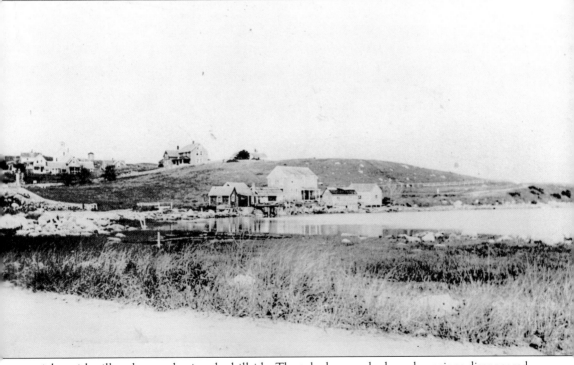

right, with village houses dotting the hillside. The telephone poles have long since disappeared. (Postcard by Defender.)

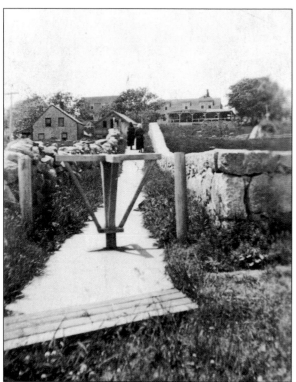

THE TURNSTILE, C. 1920. Two women head up the hill toward the Allen House. The turnstile in the foreground kept horses and cows out of the town center. The path is still used by visitors walking to and from the village, but the turnstile is gone. (Postcard by the Print Shop, New Bedford.)

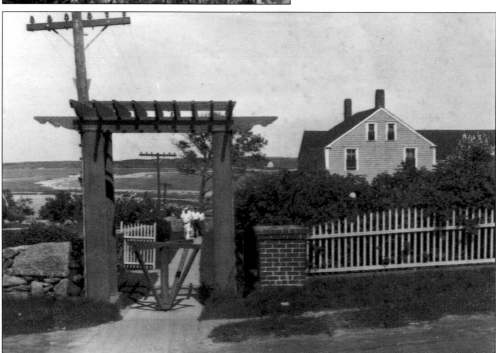

THE PERGOLA, C. 1941. Visitors stroll toward this handsome gate and turnstile. Both stood on Broadway at the other end of the path pictured in the previous image. Neither the pergola nor the turnstile exists today.

Three

FISHING AND FISHING CLUBS

Fishing and seafaring have long been the primary work of the men of Cuttyhunk. In the 1800s, lobstering was an important summer occupation. In the fall, boats went cod fishing off Sow and Pigs Reef. In the winter, the larger lobster boats dragged for quahogs with dredges. Some men also set out crab and eel pots. Otherwise, in winter the men would make lobster pots, play cards, smoke, and take things easy. Mackerel fishing with drift nets was the spring occupation. In every season, the day's catch fed the family, and the rest was sold on the mainland.

In 1864, a group of New York millionaires bought most of Cuttyhunk Island, built a large clubhouse on the bluff overlooking Vineyard Sound, and established the Cuttyhunk Fishing Club. This enterprise brought prosperity to the island, as the club's needs required regular boat and mail service, icehouses, docks, wells, and a pump house. The club provided summer and winter employment for many islanders. A decreasing supply of bass, combined with the outbreak of World War I, caused the club's demise. In 1923, its holdings were bought by William Wood, president of the American Woolen Company of Andover.

At the beginning of World War II, the U.S. Army installed coastal artillery and lookouts on Cuttyhunk and Nashawena. Fishing all but stopped as men went off to fight, and gasoline was rationed. Following the war, powerboating gained in popularity. Additional dock and marina facilities were built, and the sheltered waters of Gosnold lured sailors, sportfishermen, and pleasure boaters. By the 1950s, fishing for bass, swordfish, tuna, white marlin, and Gulf Stream dolphin was the chief occupation of most local men. Some lobstering, cod fishing, and shell fishing continued.

Cuttyhunk still attracts those drawn to the sea and its abundant resources. It also lures those looking for solitude, a slower pace, and the special benefits of a small island community.

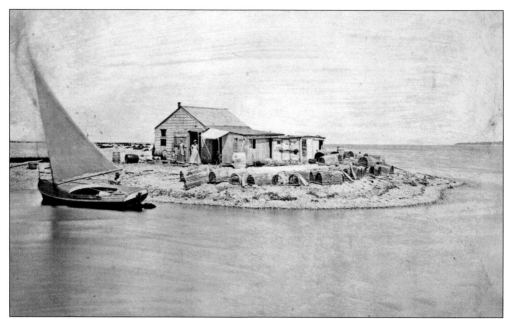

THE SPIT ON THE NORTH SIDE OF THE NARROWS, C. 1880. A little girl and two ladies in long dresses and hats stand in the doorway of a lobsterman's home. One gentleman prepares his sloop while another watches in the shade. Wooden lobster pots are lined up, ready to be set in Buzzards Bay or Vineyard Sound. Lobstering was the primary summer occupation.

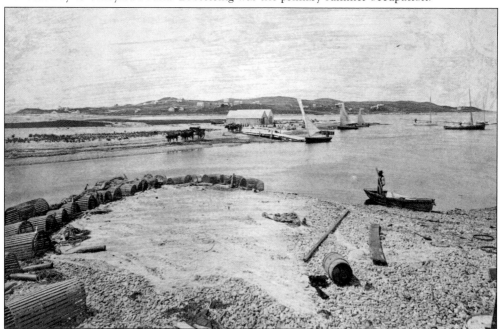

AN EARLY VIEW FROM THE SPIT, C. 1880. Looking back toward Cuttyhunk from the house pictured in the previous image, one can see the two Cuttyhunk Fishing Club storage sheds at the town landing. Wagons led by twin teams of oxen are on hand to deliver or receive freight. The boardwalk over the marsh leads to town. The Cuttyhunk Fishing Club is visible on the far left, but the familiar steeple of the island church was not built until 1881.

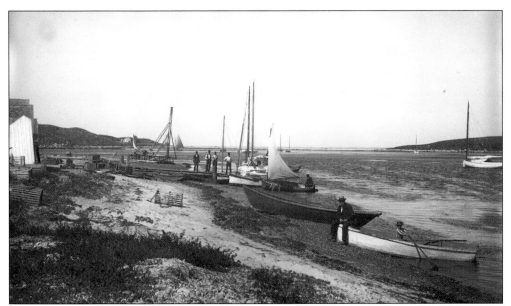

CATBOATS AT THE NARROWS, 1891. Cuttyhunk harbor was shallow, and only boats with shallow drafts could come inside. Larger boats anchored outside the harbor and offloaded passengers and freight into catboats, dories, or skiffs, such as the ones pictured here. The wooden tripod framework beyond the boats is a trap scow, used to drive stake trap pilings. (Courtesy New Bedford Whaling Museum.)

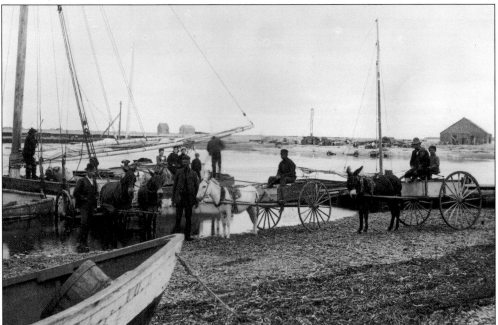

FREIGHT OFFLOADED INTO WAGONS AT THE NARROWS, 1891. Mule-drawn carts hauled freight as well as passengers. The carts were introduced to the island with the establishment of the Cuttyhunk Fishing Club in 1864. Driving the cart in the center is John Black, a respected captain of the Cuttyhunk Fishing Club boat. He was shipwrecked on Cuttyhunk and lived out his days on the island with his wife and son. (Courtesy New Bedford Whaling Museum.)

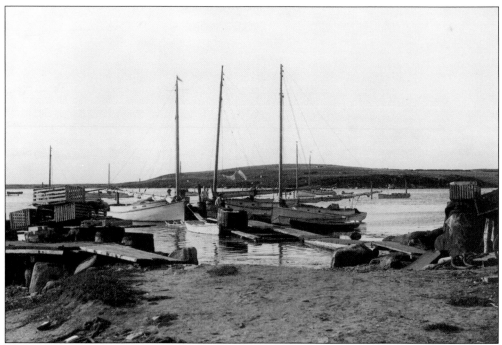

CATBOATS AT THE POINT, 1914. At the end of the workday, a fisherman aboard the *Thistle*, owned by Howard Cornell, chats with men on the dock. Planks are stretched from rock to rock, and lobster pots are stacked near barrels, ready for the day's catch. The Point (today known as the Fish Dock) has always been the workplace for islanders. (Courtesy New Bedford Whaling Museum.)

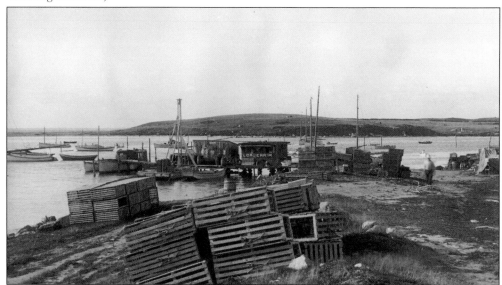

FISHERMAN'S WHARF, 1914. These shanties line the dock to the left of the boat dock seen in the previous photograph. The fishermen used the shanties for the storage of their gear. The atmosphere at the wharf was often lively as the men spun yarns, made and rigged their lobster pots, and repaired their fishing equipment. In the foreground is a trap scow for setting stake traps. (Courtesy New Bedford Whaling Museum.)

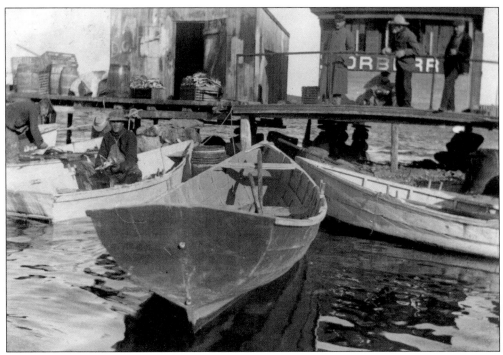

THE WHARF SHANTIES, C. 1914. Frank Veeder's shanty is on the left, with the initials F.B.V. on the door. He was a pilot, boatman, and fisherman and was awarded a lifesaving medal for heroic rescues at sea. On the right is Russell Rotch's shanty. He was a pilot, lobsterman, and one of the first surfmen of the Cuttyhunk Lifesaving Station. His shanty (with a curved roof) appears to be a pilot house salvaged from a boat.

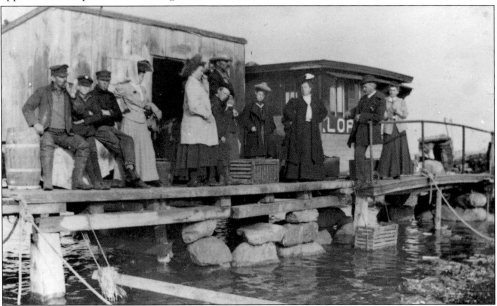

STOP TO CHAT, C. 1914. The shanties were also a meeting place for islanders. In this image, three fishermen are seated, smoking cigars, as others in more formal attire converse. The dock, shored up with stacked rocks, supports the group.

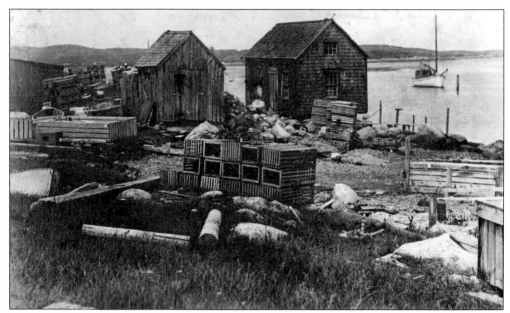

SHACKS ALONG THE HARBOR'S EDGE, C. 1920. Fishing shacks also lined the harbor's edge. These shacks were on the east side of the Point. They were not built to withstand fierce storms, and many of them did not survive the Hurricane of 1938.

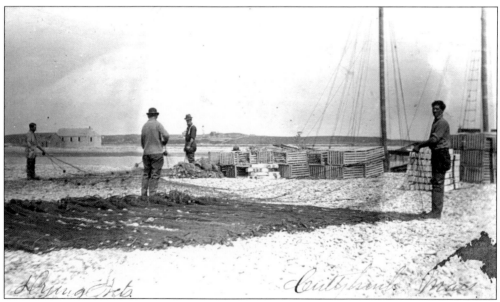

DRYING THE SEINES. Early fishermen used seines, or fishing nets, to catch mackerel, bass, bluefish, and other schooling fish. The men in this picture are drying a deep-net seine, which would be cast from a dory and hung vertically in the water, with cork floats along the top and lead weights and rings at the lower edge. Fish are caught by surrounding them with the net and then closing off the bottom with a purse line.

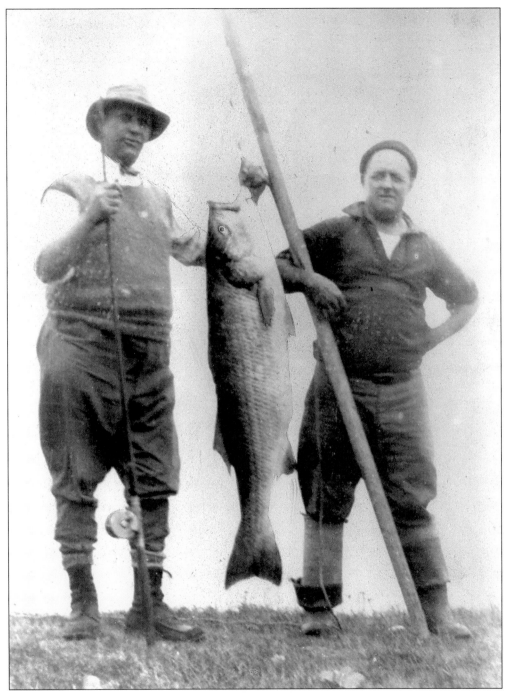

GUESS WHAT'S FOR DINNER, C. 1913. Charles B. Church (left), shown with Louis Abrams, was a local man able to afford the equipment to enjoy rod-and-reel sportfishing. The Cuttyhunk Fishing Club was for the elite member sportfishermen, while the local occupational fishermen relied on the more productive hand line trolling for bass from boats. Fish could then be harvested more efficiently and sold on the mainland. Church's home overlooked the beach to Copicut Neck, later named Church's Beach in his honor. (Courtesy Wyatt Garfield Sr. family.)

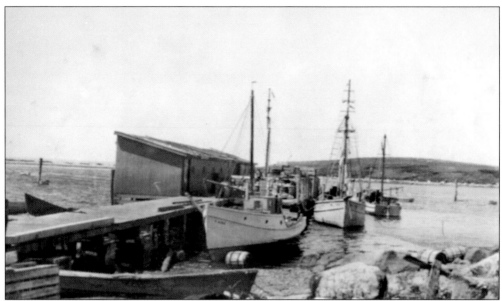

THE FISH PIER, C. 1937. As boating and yachting increased, Congress in 1936 appropriated money to make a harbor of refuge at Cuttyhunk. Dredging and boathouse construction began in 1938 and was completed in 1939. The fish pier that replaced the fishermen's shacks was divided into 10 storage sheds with plenty of dock space for lobster pot storage. By the look of the boats tied to the pier, the economic times must have improved. The center boat (with a topmast stand) is for swordfishing.

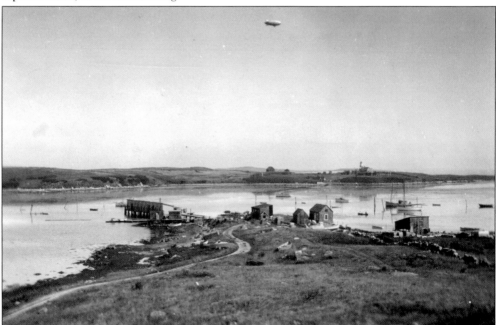

THE GOODYEAR BLIMP OVER THE PIER. The road from Four Corners winds past fishermen's shacks to the pier. Although no one seems to be rushing for a closer look, the sight of the Goodyear blimp must have caused great excitement. The harbor is calm, and the Homer farm is visible on Copicut Neck.

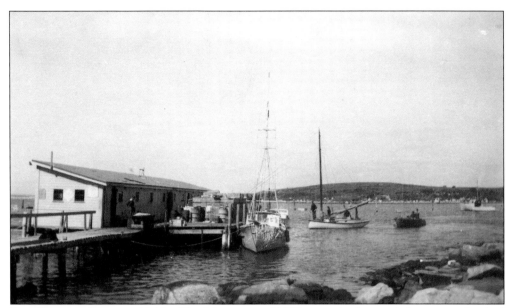

THE REBUILT PIER, C. 1940S. The Hurricane of 1938 severely damaged the pier, and it had to be rebuilt. Instead of the original 10 storage areas, the structure was extended into 11, with two windows on the south end. A guardrail was also added to the connecting dock. New jetties were built, and dredging completed the mooring basin. Times were changing—a gas-powered boat can be seen passing the catboat coming into the dock.

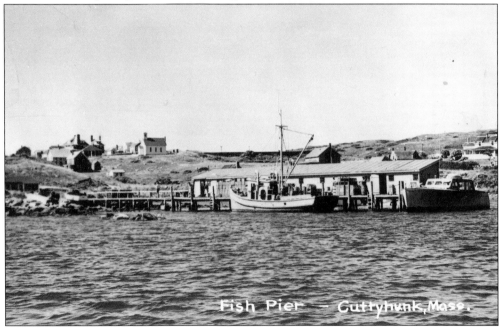

THE VILLAGE FROM THE FISH DOCK, C. 1947. In this view, the village has grown with Winter House and the road to Lookout Hill (completed by 1925). The pier is teeming with activity. The boat on the left is the *Privateer*, owned by Capt. Lloyd Bosworth. The gas-powered boat on the right is the *Mary Jo*, owned by Carlton O. Veeder, and is an indication of better times following the war. The motor-powered fishing boats change the odds against the fish.

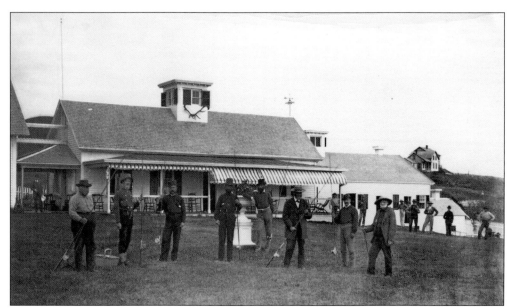

THE CUTTYHUNK FISHING CLUB, C. 1870. The Cuttyhunk Fishing Club (operated from 1864 to 1921) is seen here in its heyday with a group of wealthy New York businessmen and their chummers, or guides, in the background. Membership was limited to 75 men, and no women were allowed. Meals were lavish and the accommodations comfortable. All of the fishing was done from fishing stands. (Courtesy New Bedford Whaling Museum.)

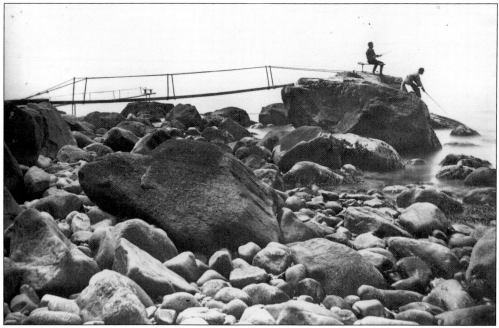

A FISHING STAND, C. 1870. The Cuttyhunk Fishing Club maintained 16 fishing stands around the island and on the southwestern shore of Nashawena. Narrow planks were laid from shore, rock to rock, out into deep water. A rope handrail was strung through iron stanchions that were leaded into the rocks. A seat at the end of the walkway could accommodate the fisherman with his chummer below. (Courtesy New Bedford Whaling Museum.)

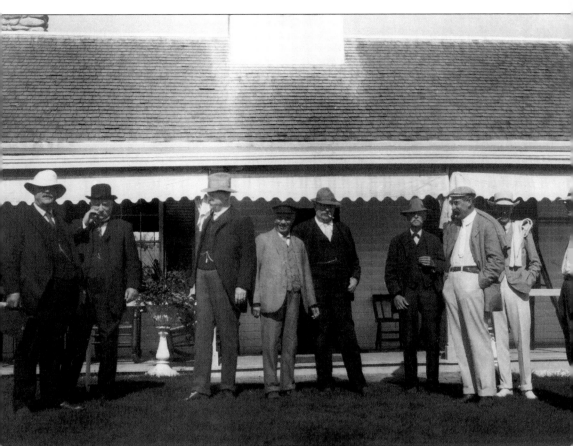

THE CLUB OF PRESIDENT MAKERS, 1902. Several distinguished members of the fishing club are pictured here. From left to right are Theodore Roosevelt (president from 1901 to 1909), William Howard Taft (president from 1909 to 1913), William Woodhull (New York millionaire and club officer), John D. Archibold (heir of Standard Oil), three unidentified men, John F. Archibold (son of John D. Archibold), and an unidentified man. Grover Cleveland was sometimes a guest of the club. After the demise of the fishing club, George H.W. Bush visited the island in his youth. Bill Clinton visited during his presidency.

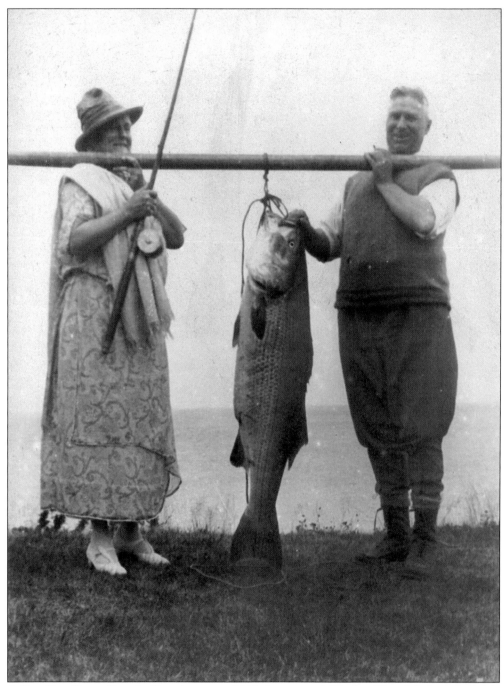

A Big One That Didn't Get Away, c. 1913. Louise and Charles Church balance a portly striper from a pole. Accessorized with rod and reel, Louise dressed up for the occasion in chiffon wrap dress and T-strap shoes. Charles sports boots and a proud grin, as he has just landed a 73-pound bass off Nashawena from a wooden, oar-powered skiff. The record striper was 60 inches long and 30.2 inches in girth. (Courtesy Wyatt Garfield Sr. family.)

WALTON "SONNY" JENKINS, 1938.
Anglers of all ages know the thrill of the
big catch on Cuttyhunk. Sonny Jenkins
proudly displays a big one with two more
bass at his feet. His uncle Francis Jenkins
worked for the Wood family.

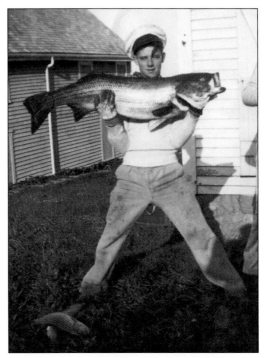

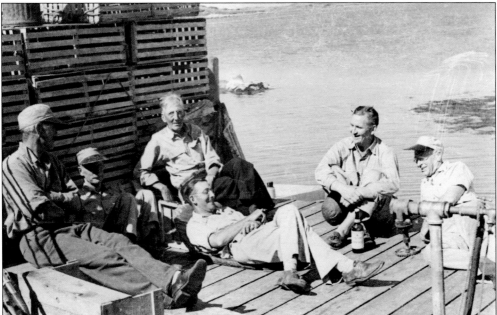

GUIDES AND FRIENDS AT THE FISH DOCK, C. 1950. From the 1950s to the 1970s, Cuttyhunk
was known as "the striped bass capital of the world." The internal combustion engine changed
fishing techniques. Following World War II, guides began taking fishermen out in small bass
boats to troll with rigged whole eels or eel skins. Well-known bass and big-game fisherman
Irwin Winslow "Coot" Hall (lying down, front center) developed the modern bass boat. In the
back, from left to right, are John Cornell, Jack MacKay, Irwin C. Hall (seaman, master mariner,
yacht captain, and skilled bass guide), Mel Dorr Sr., and Winston Valentine.

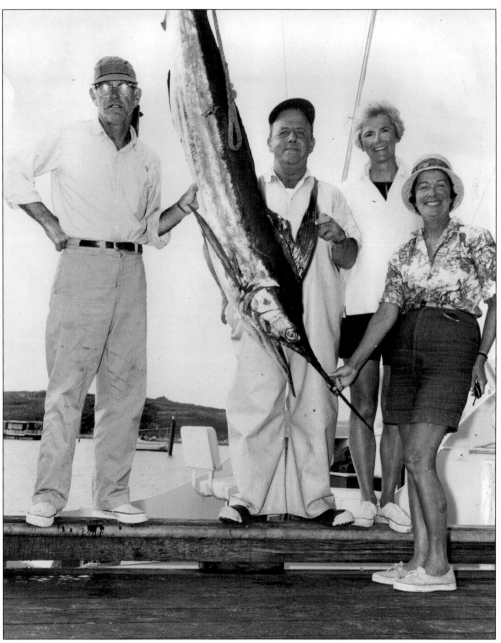

A Broad Smile for the Broadbill, 1965. Angler Janet Bosworth weighs in her winning white marlin at 79 pounds at the conclusion of the International Women's Fishing Association Broadbill Fishing Tournament. The tournament was one of three organized by the association on Cuttyhunk from 1965 to 1967. From 1960 to 1973, Cuttyhunk also hosted the First International Swordfishing Tournament, and Bosworth enthusiastically participated nine years without snagging a swordfish. Pictured from left to right are Alpheus P. Tilton (captain of Bosworth's boat *Sea Bird*), crew member Alan Potter, photojournalist Jan Wilder, and Janet Bosworth.

Four

HOUSES GREAT AND SMALL

None of the island's earliest houses has survived. They were undoubtedly small, built low to withstand the almost constant wind, and were located where water for wells was available. Two families are known to have lived on the island in 1761. By 1850, however, 30 families were listed in the census. Many of their houses still exist in the village. They are plain in appearance yet roomy enough to take in boarders. Most have faced the harbor or its narrow entrance, which were the centers of the community's livelihood.

Over the years, island houses have often been in a state of change—adding a wing here, a porch there, and even a second story. A few have been moved from one place to another, and occasional hurricanes have swept some away. Thrifty island homeowners have used timbers from shipwrecks in their construction. Coal salvaged from the wreck of the whaling ship *Wanderer* in 1924 warmed many houses during the following winter. During World War II, the army constructed a communication center on the island, disguising it to look like a small fishing village. After the war, two of these buildings were moved and became houses for summer residents.

The island was most profoundly changed by the building of the Cuttyhunk Fishing Club in 1864, by William Wood's first house (Avalon) in 1909, and by his Winter House in 1917. These houses remain prominent island landmarks and mark the dramatic change from a small, self-sufficient fishing village to one now open to a different and substantially more affluent group of summer residents.

The Allen-Daggett House, c. Early 1900s. This house, also known as the Allen Homestead or Grandma Daggett's, was the oldest house on Cuttyhunk. It was located just north of the current Coast Guard barracks. In 1842, Holder Allen and his wife, Mary Slocum Allen, purchased the house from Holder's uncles, Holder and Peleg Slocum. They brought up their 13 children there.

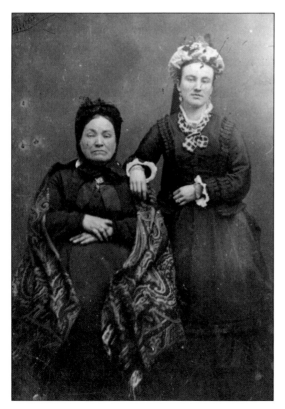

Mary Slocum Allen-Daggett (1815–1897). This formidable-looking woman was better known on the island as Grandma Daggett. She is seated by her daughter, Henrietta Allen Akin. Henrietta was the wife of Timothy Akin Jr., one of the five Cuttyhunk men who drowned in the rescue attempt of the brig *Aquatic* in 1893. As Henrietta died two years before her husband, the elderly Grandma Daggett helped bring up the seven orphaned Akin children. On the back of this photograph, one of the Akin orphans wrote, "She was good to us children."

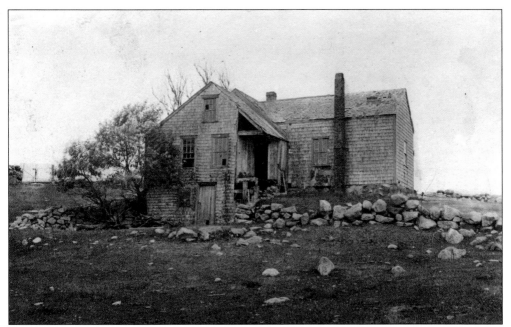

THE ALLEN-DAGGETT HOUSE, C. EARLY 1900S. This view of the back of the house clearly shows that early island life had few embellishments and no luxuries. After Holder Allen's death in 1872, his wife, Mary, inherited the house. She subsequently married Alonzo Daggett, who became the island's first postmaster. By the mid-1920s, the house had deteriorated badly and was torn down. With its removal, a part of the island's early history was lost.

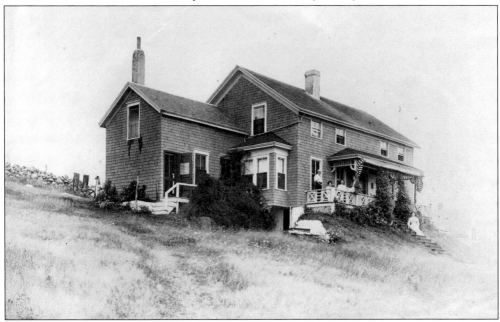

THE CHARLES ALLEN HOUSE, C. EARLY 1900S. The festive decorations indicate that this well-dressed group has gathered to celebrate the Fourth of July. The plain yet pleasant exterior of the house and its comfortable porch are typical of island homes of the period. The house is still located on Broadway but has been substantially modernized.

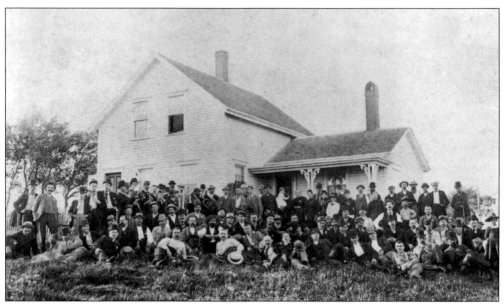

THE HOMER FARM, C. 1890. Summer residences have replaced this farmhouse property on the part of Cuttyhunk known as Copicut Neck. Some island faces are recognizable in the photograph, but it is unknown what occasion brought such a large group together and why there are so few women present.

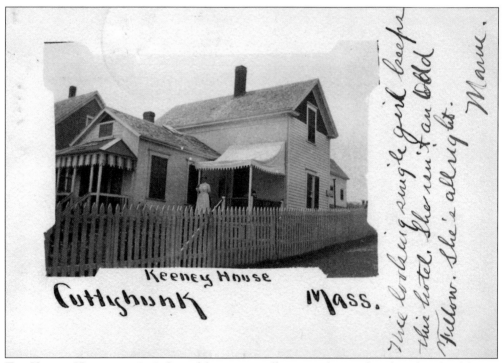

THE KEENEY HOUSE, C. 1905. One of the many small rooming houses found on the island during the heyday of visitor popularity, the Keeney house has retained much of its original appearance. The "nice looking single girl" is Elizabeth Keeney, who later married Tom Dowling.

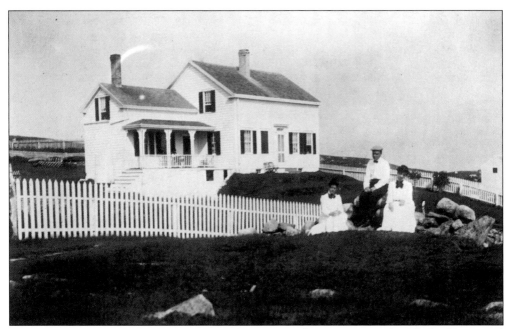

THE ALONZO VEEDER HOUSE, C. 1902. Summer residents now own the Veeder House and have added a second porch. The picket fence is gone, but both porches still offer a fine view of the harbor.

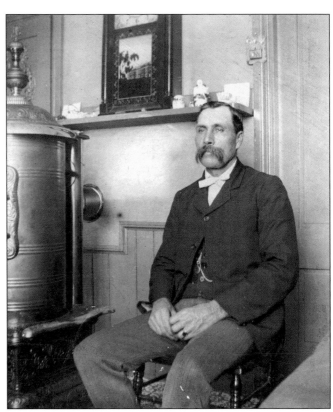

ALONZO VEEDER (1851–1907). Alonzo Veeder was very active in town affairs and, at one time, held as many as seven town offices. Several Veeder descendants now live on the island and bear a striking resemblance to their handsome forebear.

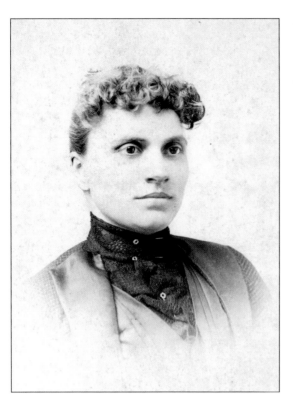

ELIZABETH VEEDER BOSWORTH (1863–1930). Elizabeth Veeder Bosworth opened her family's home as a boardinghouse in 1888. She and her husband, David, subsequently enlarged the house, and it became well known for its excellent meals.

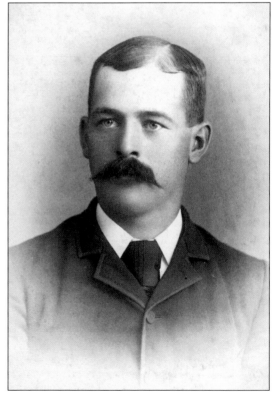

DAVID BOSWORTH (1863–1935). David Bosworth, Elizabeth's husband, was also from an old island family. He was the proprietor of the town's only store for many years. After her parents' deaths, their daughter Estella Bosworth Snow took over managing the Bosworth House. Still later, Estella's daughter Gladys Snow Gage continued to run it with her husband, John Gage.

THE BOSWORTH HOUSE, C. 1890. This is an early view of one of the island's largest and most popular boardinghouses. Until summer residents purchased the Bosworth House in 1984, it was a favorite of visiting fishermen and yachtsmen.

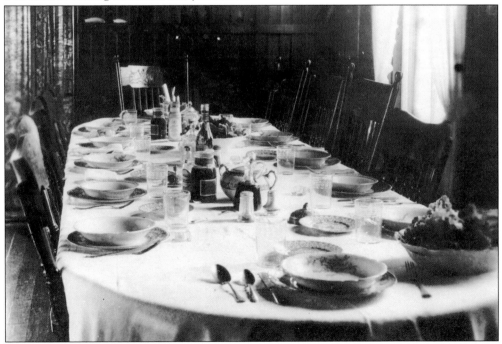

THE BOSWORTH HOUSE DINING ROOM, 1929. Guests were offered substantial meals of lobster meat, coleslaw, and corn on the cob, with watermelon or pies served for dessert. Boardinghouses could anticipate how many guests to expect by the number of hoots the crowded ferry sounded while still offshore.

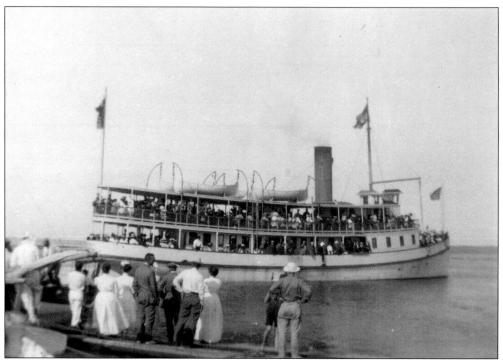

THE STEAMER *GOSNOLD*, C. 1906–1918. This crowded ferry brought the island mail and often carried more than 400 passengers coming to Cuttyhunk for a shore dinner or a seaside holiday. Well-wishers in suits and starched dresses stand on the small dock near today's site of the much larger town dock.

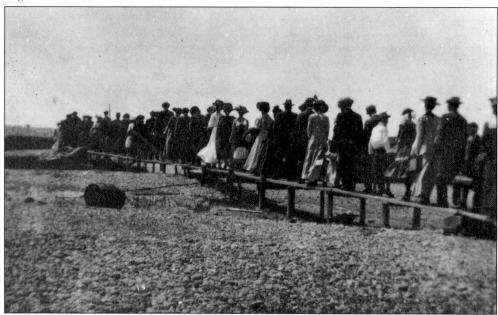

THE BOARDWALK, C. 1904. The boardwalk kept visitors' feet dry as they walked to and from the ferry to the path leading to the center of town. The town removed the boardwalk when the road to the town dock was paved in the 1930s.

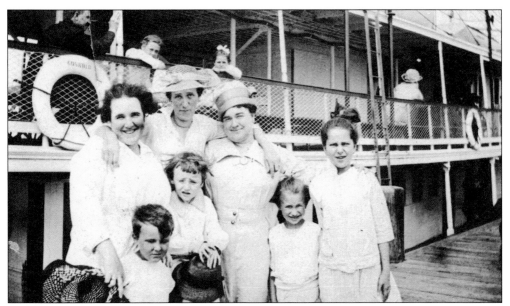

READY FOR FUN, EARLY 1900S. This smiling group is perhaps just off the *Gosnold* or ready to board. They are among the many passengers who came to the island during the heyday of the boardinghouses either for lunch or perhaps a longer visit.

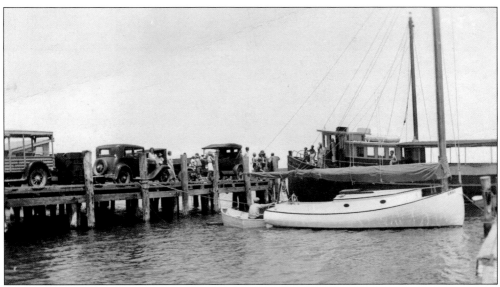

THE *ALERT I*, C. 1941. Roadsters and beach wagons line up to pick up passengers and freight at the town dock. The *Alert's* dark-green color is quite different from the later white (with orange trim) that most island travelers recall. A round-trip fare in 1919 was $1.30, compared to $17 today. (Postcard by Defender.)

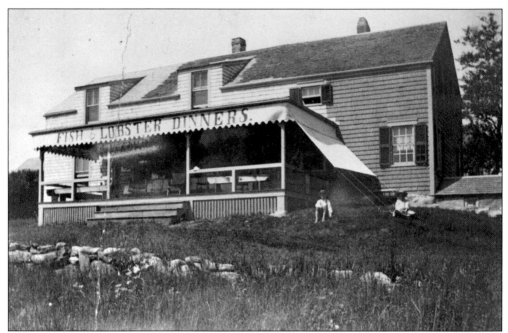

THE POPLARS, C. 1915. The Poplars, later called the Allen House, was also well known for its inexpensive lobster dinners. Like the Bosworth House, it remained a popular boardinghouse and inn for bass fishermen and yachtsmen until it closed. Summer residents purchased the Allen House in 1993.

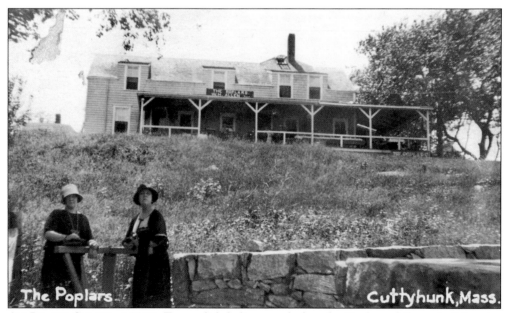

AN ISLAND STROLL, 1920s. Two stylish ladies pose before the Poplars while on holiday. An addition on the right and an expanded porch indicate a thriving business. Shorts and bathing suits are now more usual outfits seen on the same path that leads from the dock to the village. (Postcard by the Print Shop, New Bedford.)

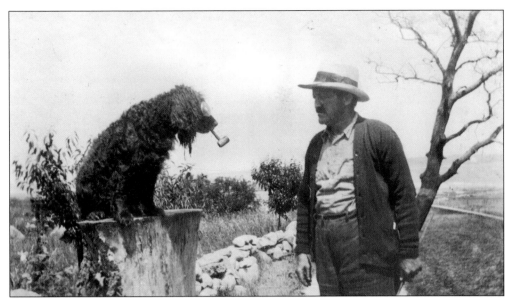

WALTER "WALL" ALLEN (1868–1937) WITH A FRIEND. Walter Allen appears to be counseling his dog on the perils of smoking. He and his wife, Elizabeth Jamieson Allen, were the original proprietors of the Poplars. Allen was also an active and well-liked member of the U.S. Life-Saving Service.

AN ISLAND LIMOUSINE. Clarence Allen (1899–1974), the son of Walter Allen, was the last member of the family to run the Allen House. He is standing with his wife, Lucille, beside the van that carried guests' luggage up from the ferry *Alert*. Lucille Allen was the island nurse for many years.

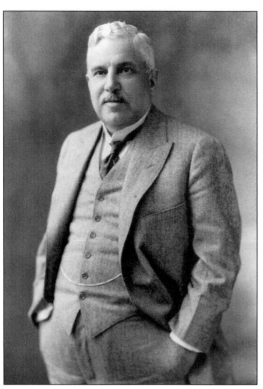

WILLIAM MADISON WOOD (1858–1926). As president of the American Woolen Company, William Wood was a commanding presence and a major landowner on the island after he bought the Cuttyhunk Fishing Club's holdings in 1923. He not only built two large homes (Avalon and Winter House) but installed the present power plant. Thanks to his foresight, the island's power lines are all underground, ensuring safety during nor'easters and hurricanes.

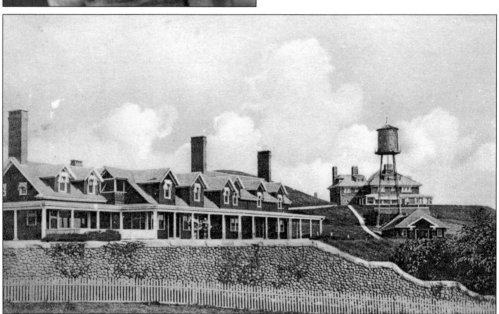

AVALON, WILLIAM WOOD'S FIRST HOUSE, 1929. Wood built this substantial house in 1909. His second home, Winter House, and his bowling alley appear on the right, as does the town's first water tower. Avalon has survived many transitions. It has been a recuperation hospital for World War I army officers, a summer retreat for friends of Wood's son Cornelius in the 1920s, and an inn under a series of owners and managers. It is now privately owned. (Postcard by Henry A. Dickerson, Taunton.)

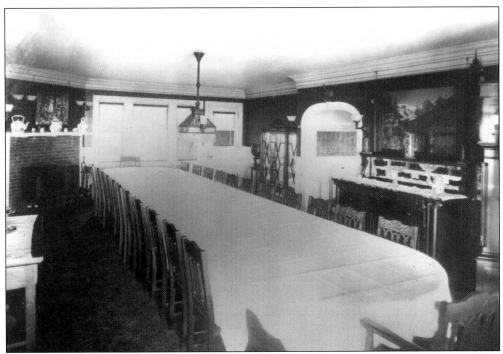

THE DINING ROOM AT AVALON, C. 1917. The spacious room and large table could seat 24 guests. Avalon originally contained 11 bedrooms and 9 bathrooms, a large living room, and a pool room, as well as a big kitchen and pantries. As in Winter House, a considerable staff was needed to keep the house and grounds running smoothly.

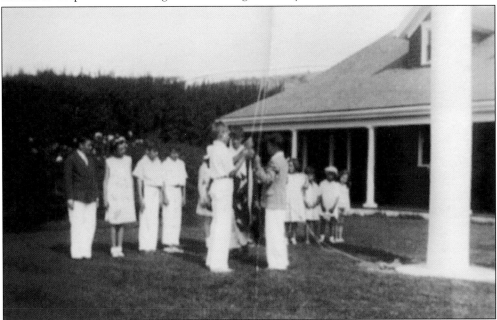

RAISING THE FLAG. During the 1920s and early 1930s, Cornelius Wood's children and their friends gathered each morning for an official raising of the flag. The boys wore white trousers, and the girls appeared in dresses.

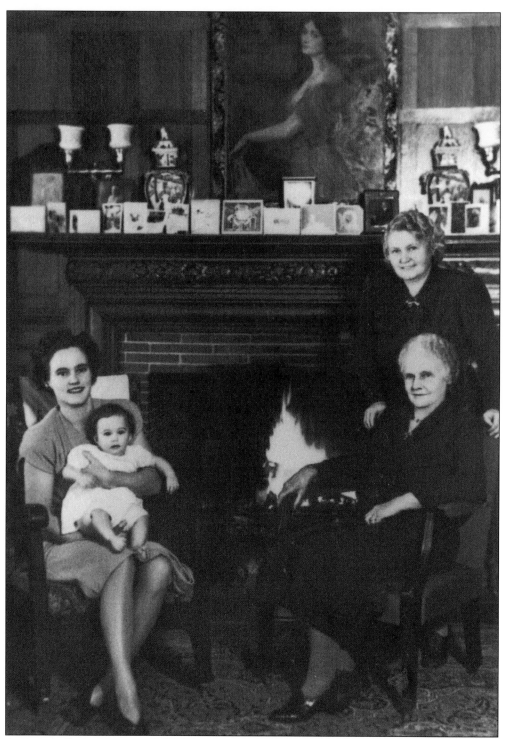

A FAMILY PORTRAIT, C. 1946. The present owner of Winter House, Oriel Wood Winet Ponzecchi, is seated with her daughter Susan Winet on her lap. Seated to the right is her grandmother Mina Merrill Prindle, and standing is her mother, Muriel Prindle Wood.

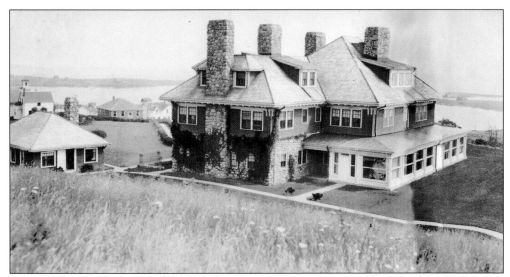

WINTER HOUSE. William Wood's estate included this large house, a tennis court, and a bowling alley. The interior of the house is still decorated with stone fireplaces, walnut paneling, and much of the handsome, formal furniture of that period. The small building on the left is the annex. At one time, it housed a barber chair and one of the island's few telephones.

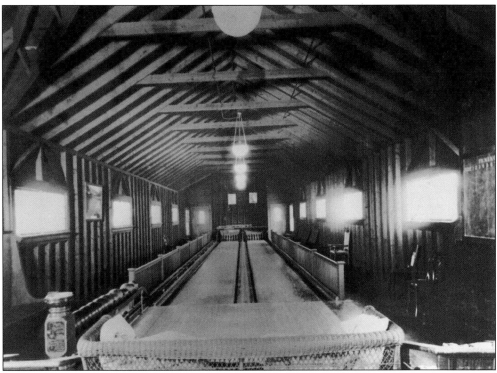

THE BOWLING ALLEY. Guests bowled with standard pins, and children (either willingly or for a modest fee) were persuaded to be pin setters. The ball-return post and scoreboard still remain, but the rest of the structure has been remodeled as a summer residence.

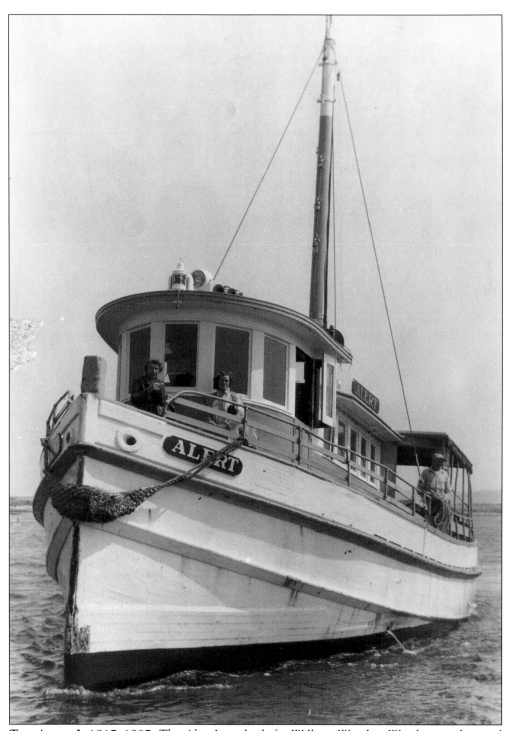

THE ALERT I, 1917–1987. The *Alert I* was built for William Wood in Wareham and carried the building materials for his second home, Winter House. On its completion, it became the island ferry, carrying passengers, freight, mail, and groceries on a daily basis. The *Alert II* replaced it in 1987. The *Alert I* is now for sale in New London, Connecticut.

Five

LIGHTHOUSES AND LIFESAVING

During the 18th and 19th centuries, Vineyard Sound and Buzzards Bay were among the most dangerous shipping channels on the East Coast. The prevailing southwest winds, strong currents, and heavy fog contributed to driving many sailing ships aground in the area. The first lighthouse on the Elizabeth Islands was built in 1759 at Tarpaulin Cove on Naushon.

The first lighthouse on Cuttyhunk was built in 1822. It was located at the westernmost point of the island near the treacherous Sow and Pigs Reef, which separates Buzzards Bay and Vineyard Sound. The Cuttyhunk lighthouse had only one attendant. His duties included keeping the light cleaned, filled with oil, and burning between sunset and dawn. He sounded a fog signal when needed and kept buildings and equipment in good working order. The keeper often assisted in rescues when a ship struck the nearby reef.

After the formation of the Massachusetts Humane Society in 1786, volunteers built huts along the shoreline and stocked them with emergency supplies. By 1847, three huts had been built on Cuttyhunk and one on Nashawena. These were all equipped with lifeboats manned by volunteers. Many dramatic rescues were made under appalling conditions. In 1851 alone, 6,676 ships passed Cuttyhunk in three months—4,991 schooners, 954 sloops, 544 brigs, 182 ships, and 5 steamers.

In 1870, the federal government finally supported the Massachusetts Humane Society's efforts by organizing and financing the U.S. Life-Saving Service. In 1889, a lifesaving station was built on the Elizabeth Islands, located on Cuttyhunk near Canapitsit Channel so that aid could be sent quickly to the Graveyard and Sow and Pigs Reef. In 1915, the U.S. Life-Saving Service and the Revenue Cutter Service merged to become the modern Coast Guard. As sailing vessels were phased out of commercial trade, rescues became less frequent. On March 2, 1964, the Coast Guard station on Cuttyhunk closed. The Elizabeth Islands are now served by the stations at Menemsha and Woods Hole.

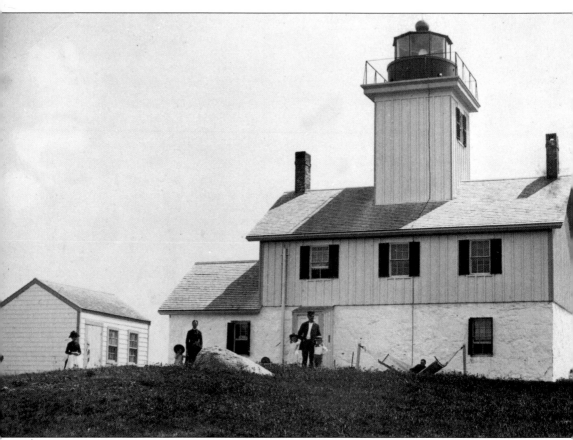

THE FIRST CUTTYHUNK LIGHTHOUSE, C. 1860s. The one-story, 34-by-20-foot lighthouse was originally built of stone at the remote west end of the island in 1823. The separate light tower had an octagon iron lantern with 21 lights in each section. It burned porpoise and, later, sperm oil. The tower was twice reinforced with brick and was demolished in 1860. At that time, a second story was added to the keeper's house, seen here, and a new fixed white light (visible for 12 miles) was placed 42 feet atop the dwelling. S. Austin Smith, keeper from 1864 to 1868, recorded on February 13, 1864, "Heavy weather. Employed washing, cooking, cleaning the light. This is lonesome. We are all sick."

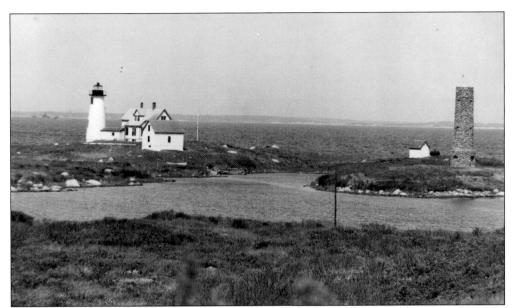

THE SECOND CUTTYHUNK LIGHTHOUSE, C. 1905. After the earlier lighthouse was demolished in 1892, a new frame building was constructed and connected by a covered way to the 40-foot circular tower. In 1903, a small stone house was built nearby to store the sperm oil or kerosene. The oil was transported by ship in 55-gallon drums. The drums were then floated through the opening to the West End Pond and rolled up the beach. The lighthouse and dwelling were demolished in 1947 and replaced with a skeleton steel light tower, now powered by solar panels.

THE WASH POND AT THE WEST END, C. 1905. The West End Pond is pictured with the Wash Pond to the right. The Wash Pond was where the island sheep were washed and picked clean of sticks and burrs before being shorn. The keeper's dwelling and newly dedicated Gosnold monument are visible across the pond. Alice Terpeny, the daughter of the lighthouse keeper in the early 1900s, recalled skating across the pond to school in winter and rowing across with her father in fair weather.

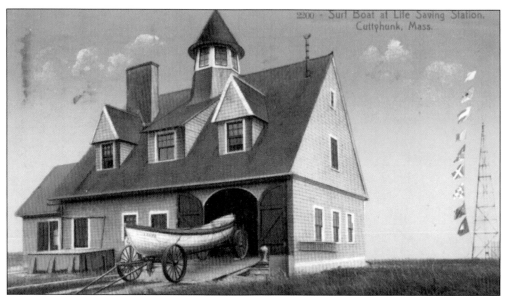

THE U.S. LIFESAVING STATION, C. 1890. The lifesaving station was established on Cuttyhunk in 1889 to support the work of the Massachusetts Humane Society. This station was placed close to Canapitsit so aid could be dispatched quickly to ships in trouble. A keeper and six surfmen manned the station. The surfboat shown on its carriage was hauled along the track and launched into the water. (Postcard by H.S. Hutchinson and Company, New Bedford.)

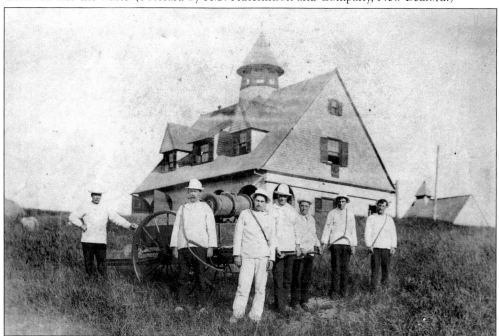

LIFESAVERS AT THE CANAPITSIT STATION, C. 1903. Pictured are six surfmen with the keeper, Capt. Darius Weekes (far left). They are draped in the rope used in the breeches buoy rescue. The men drilled constantly in the use of the breeches buoy, boat handling, and other rescue skills. The surfmen received $50 per month plus living quarters but had to supply their own food and clothing. The keeper received a salary of $800 per year. Irwin C. Hall is sixth from the left.

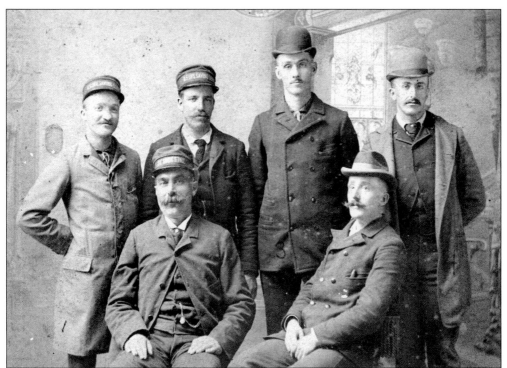

A FORMAL PORTRAIT OF THE LIFESAVING CREW, C. 1915. This portrait of the crew required formal dress and a trip to New Bedford for the sitting. Some wore derbies, while others wore the official U.S. Life-Saving Service hats. Some ladies were known to wear the hat bands as belts. From left to right are the following: (front row) Capt. Darius Weekes, with a watch fob and hastily buttoned jacket, and Willard Church, with a cigar in his pocket; (back row) Walter Allen, Tom Jones, Humphrey Jamieson, and Josiah Tilton.

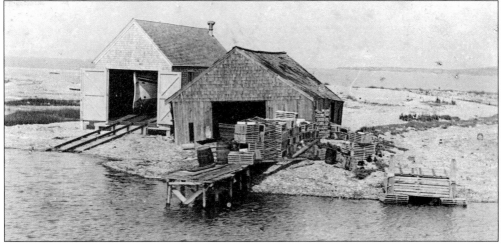

THE LIFESAVING BOATHOUSE AND LOBSTER SHACK. These structures stood on the north side of the Narrows, facing the harbor. On the left is the boathouse with rails into the water and surfboat on its cradle prepared for an emergency. This boathouse later burned down and another (called the Betsy Boathouse) was erected on the south side of the channel, halfway down the beach. On the right is a lobster shack, which disappeared in a storm.

TRAINING AT THE STATION, C. 1895. The crew at the lifesaving station practices rescue maneuvers that would allow them to transport victims from ship to shore. In the background is the gun cart with large spools of line used in the breeches buoy rescue. (Postcard by H.S. Hutchinson and Company, New Bedford.)

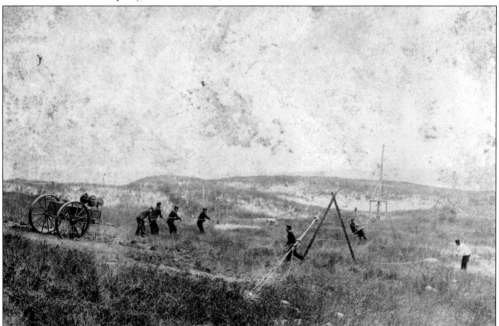

THE BREECHES BUOY DRILL, C. 1900. In the breeches buoy rescue, the gun cart is positioned on the bank about 70 feet above the sea. A shot is fired at the ship's mast, and the line is secured between the mast and the shearleg drill pole on shore. The breeches buoy, which resembles a life preserver with pants attached, is hauled out to the ship by surfmen. Crew members don it and are pulled ashore one at a time.

THE AKIN FAMILY AT THE
STATION, C. 1905. In a letter
dated February 22, 1893, Timothy
Akin Jr. described a breeches
buoy rescue of nine men aboard
a wrecked four-masted schooner.
Two days later, he and four other
lifesavers perished in an attempted
rescue of the brig *Aquatic*. Akin
family members are shown here
about 12 years later.

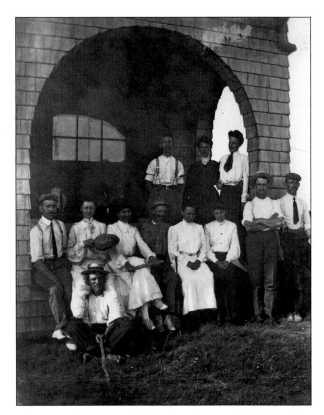

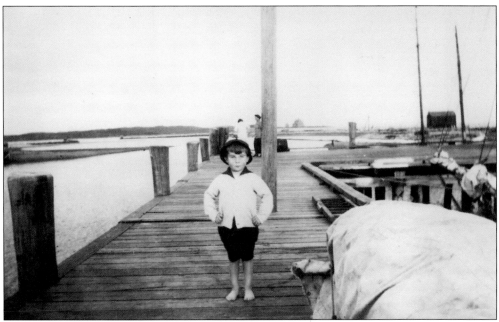

THE LITTLEST SAILOR, C. 1935. An unidentified boy in sailor suit and hat stands at attention
at the town dock. The lifesaving station and boathouse still stand in the background. They were
replaced by the new Coast Guard station in 1937.

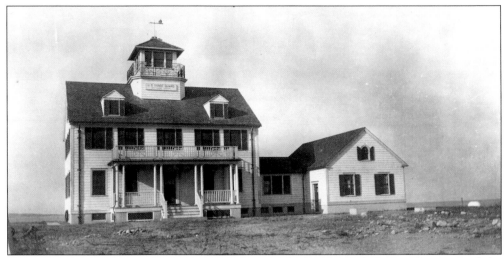

THE NEW COAST GUARD STATION, 1937. In 1915, the U.S. Life-Saving Service and the Revenue Cutter Service joined to become the modern Coast Guard. Its principal duties were rescuing vessels in distress, enforcing the rules of navigation, preventing smuggling, and overseeing merchant ships. By the spring of 1937, the first lifesaving station was torn down and replaced by an impressive new white building at Canapitsit Channel. It withstood the violent Hurricane of 1938, which caused severe damage to the island.

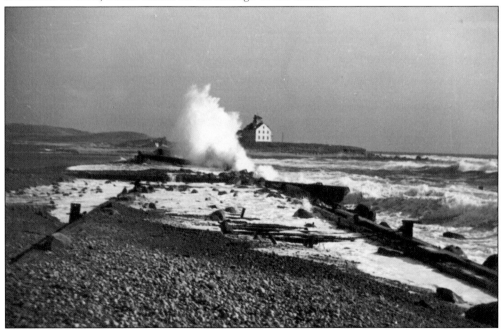

THE COAST GUARD STATION FROM BARGES BEACH, 1950. During the Hurricane of 1944, the spit connecting the station with Cuttyhunk was breached. The shoaling that resulted often kept the ferry *Alert* from reaching the dock. Passengers and freight had to be offloaded in the outer harbor. To stabilize the beach erosion, 10 railroad car floats were towed from New York, floated in on the tides, anchored in place as the tide receded, and filled with rubble. Since 1949 (when the engineering feat took place), this stretch of reconstituted land has been known as Barges Beach.

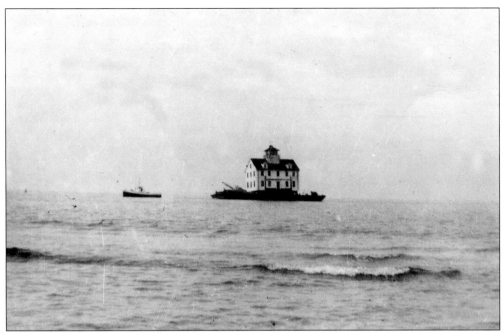

THE COAST GUARD STATION MOVED TO MENEMSHA, 1952. In 1952, this second station was jacked up, rolled down the beach onto a barge, and towed across Vineyard Sound to Menemsha. One account says the move was made in heavy fog, and a fisherman stunned by the mirage swore off liquor for life. The Coast Guard boathouse that had been attached to the station remains and is now a private home.

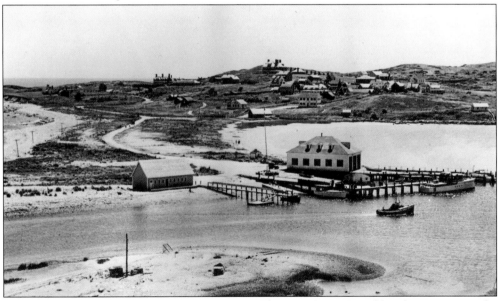

THE NEW COAST GUARD BOATHOUSE, 1954. The new Coast Guard boathouse next to the town dock was completed just after the Hurricane of 1938. The two-story station house pictured in the distance was built *c.* 1953 and replaced the station moved to Menemsha. The building to the left of the boathouse is the Cornelius Wood family's bathhouse, which disappeared in 1954 during Hurricane Carol.

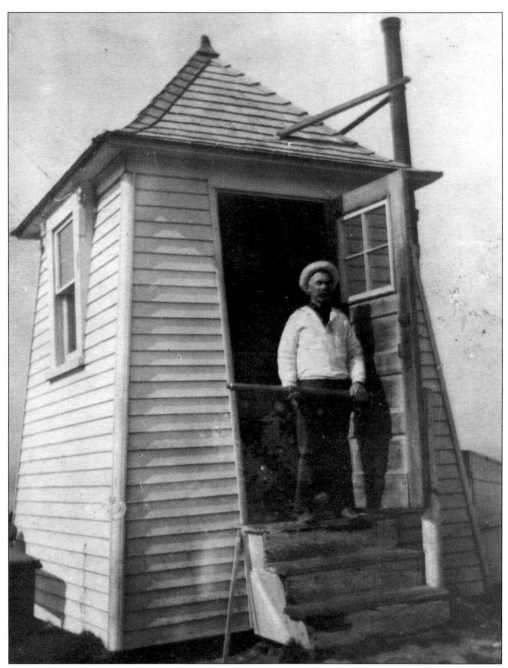

THE LOOKOUT STATION, C. 1900. The lookout station was positioned at the highest point on the island that afforded a 360-degree view of Buzzards Bay and Vineyard Sound in fair weather. It was manned first by the lifesavers and later by the Coast Guard. This lifesaver holds a "long glass" used to scan the horizon. Tourists occasionally mistook the station for a "comfort castle," or outhouse. Margaret Brewer describes a morning at the lookout. She counted more than 50 boats in the sound, from the small ones with one mast to the five-masted schooners. The lifesavers also patrolled the coast of Cuttyhunk on foot or horseback. At night they carried a lantern, a Coston light, and rockets to alert vessels that might be headed for disaster.

Six

DISASTERS

While the sea has long been a source of livelihood for the island, it has also taken its toll. Unmarked graves in the island cemetery hold the remains of men whose bodies washed ashore after a shipwreck and whose names were never known. Other stones bear the names of island men who died in rescue attempts.

Because a fatal combination of strong winds, high seas, and fog often drove sailing ships aground on the south shores of the Elizabeth Islands, that area was known as the Graveyard. A long list of wrecks found in reports of the U.S. Life-Saving Service attests to the dangers that were ever-present in the lives of those who took to the sea. Island men risked their lives each time they climbed into a surfboat and rowed out through stormy seas to rescue men clinging to a wrecked ship.

The worst tragedy for the island involved the wreck of the brig *Aquatic* in 1893. On a stormy February night, Capt. Timothy Akin Jr. and five other men from the Massachusetts Humane Society launched their surfboat into the breakers and set out to rescue the men on the wrecked ship. While rowing against tremendous waves, the six men were washed overboard. All but one, who was pulled aboard the wreck, drowned. It was a staggering loss to the small community.

Other wrecks abound, but the wreck of the bark *Wanderer* has remained famous in Cuttyhunk history, as it was the last whaling ship to leave New Bedford. The spectacle of the large ship wedged on the rocks at the West End brought all the island out to watch. Fortunately, there was no loss of life.

Hurricanes, too, have taken their toll in the loss of livelihood. High seas have swept away houses, have damaged boats, and have destroyed lobster pots and fishing gear. Whether in calm waters or sudden gales, respect for the sea is a given for those who live nearby and earn a living from it.

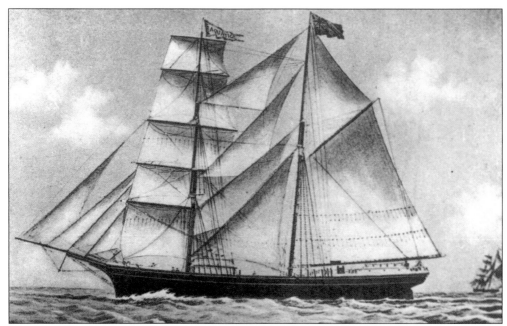

THE BRIG AQUATIC, 1893. When the wreck was reported, Capt. Timothy Akin Jr. of the Massachusetts Humane Society launched his surfboat with his brother Fred, Hiram Jackson, Josiah and Isaiah Tilton, and Eugene Brightman aboard. During the attempt, all but one man, Josiah Tilton, drowned. This was a wrenching disaster for the small island community. It is ironic that all aboard the *Aquatic* were rescued the next day by the crews from the rival U.S. Life-Saving Service. This picture is from an 1893 booklet entitled *Cuttyhunk, Home of Heroes.*

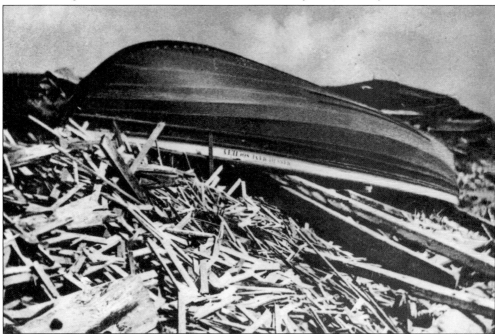

AN OVERTURNED SURFBOAT. This surfboat lying amid the mass of rubble left after the storm gives mute testimony to the island's loss of life. On its side are the words "Mass Humane Society."

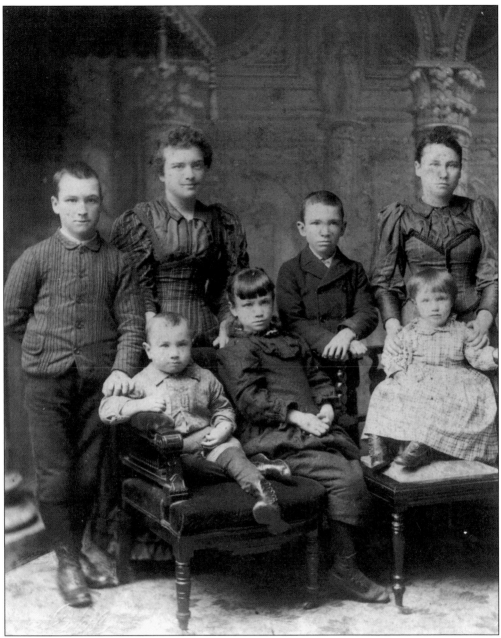

THE AKIN ORPHANS, 1896. Although the other men who died during the *Aquatic* rescue effort also left children behind, the story of Timothy Akin Jr.'s family is particularly poignant. As he had already lost his wife, Henrietta, after childbirth in 1891, his seven children were left orphaned. Support for the children was difficult, and it was not until the eldest daughter, Etta, married that she was able to care for and support them. The Akin children are, from left to right, as follows: (front row, sitting) Orin, Ruth, and Cora; (back row, standing) Alvah, Eva, Ralph, and Henrietta (Etta).

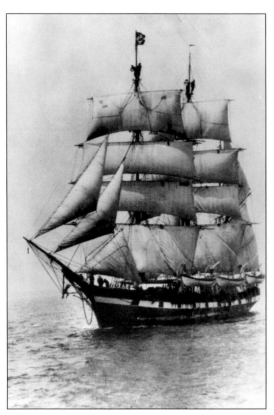

THE BARK WANDERER. With flags flying and under full sail, the *Wanderer* is pictured here representing the *Charles W. Morgan* in the 1921 film *Down to the Sea in Ships*. The whaleboats along the side would have been launched when a lookout spotted a whale. The boats were later used by the crew to reach safety when the ship was wrecked. (Courtesy New Bedford Whaling Museum.)

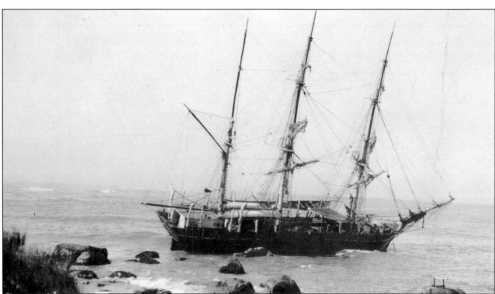

THE BARK WANDERER WRECKED, AUGUST 26, 1924. The *Wanderer* was the last whaling ship to sail out of New Bedford. Before setting out to sea, it was anchored off Cuttyhunk while the captain was ashore rounding up more crew. When a sudden, violent storm hit, the men on board were unable to keep the anchor from dragging, and the ship went aground on the rocks off Cuttyhunk.

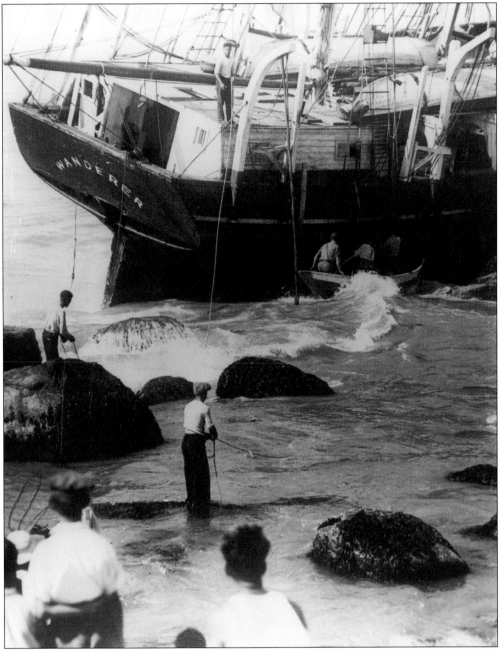

THE WANDERER AGROUND, 1924. The ship was eventually declared a total wreck, but the incident was not without some profit to islanders. Much of the cargo was brought ashore, resulting in a need to guard the salvage with armed watchmen. Island homes were considerably warmer the following winter because of the coal that had been in the *Wanderer's* hold.

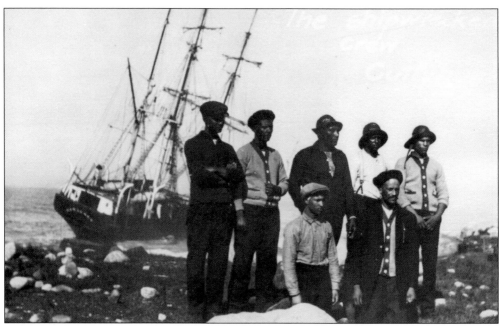

THE CREW OF THE WANDERER, 1924. Tired men pose before the wreck of their ship. An islander who viewed the scene as a young boy recalls that the first mate of the ship's whaleboat ordered his men to lie down in the boat's bilges as ballast. He then skillfully steered the boat in on a wave and landed some 30 feet up on the shore. One of the crew climbed out, holding a precious belonging—his guitar.

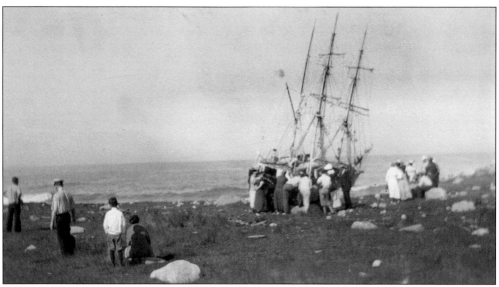

A CROWD GATHERS, 1924. Clustered about the ship, these curious islanders are perhaps looking for a few souvenirs to take home. They must have been successful in their search, as is evident in some of the artifacts now in the Cuttyhunk Historical Society's collection. Because there was no loss of life resulting from the wreck, a holiday atmosphere seems to pervade the picture.

ALICE AND GEORGE STETSON. George Stetson, a member of an old island family, met Alice Terpeny, the lighthouse keeper's daughter, when she was working at one of the island boardinghouses. The cheery-looking couple already had two children, and she was pregnant with a third when his ship foundered in a freak storm. Stetson and his crew of five were all lost.

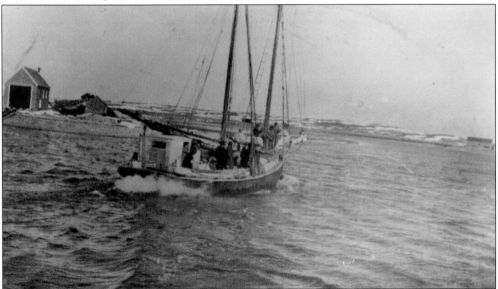

THE *ALICE L. STETSON*, 1917. George Stetson's schooner *Alice L. Stetson* is seen here passing through the Narrows at Cuttyhunk with a full crew aboard. George Stetson was only 29 years old when he went down with his ship off Highland Light on Cape Cod.

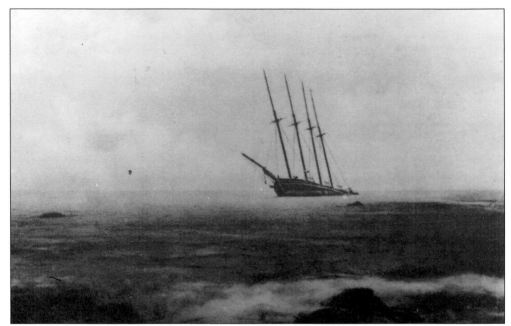

THE SCHOONER *DOUGLAS DEARBORN*, 1893. Carrying a load of coal, the schooner went aground on the south side of Cuttyhunk. Members of the lifesaving station crew rescued the men on board by breeches buoy. After their rescue, three crew members spent the night at the station and six in island homes.

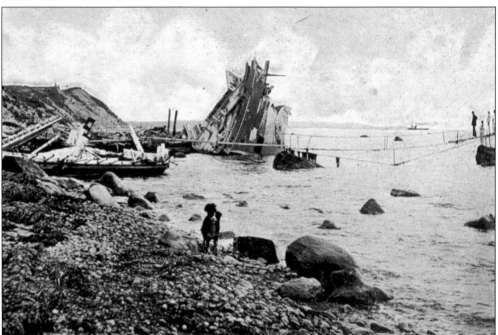

A WRECK ON CUTTYHUNK. The south shores of the Elizabeth Islands were known as the Graveyard because a combination of strong winds, heavy surf, and fog often forced sailing ships onto their rocky coasts. The men observing this unnamed wreck are standing on one of the Cuttyhunk Fishing Club's fishing stands. (Postcard by the Souvenir Postcard Company.)

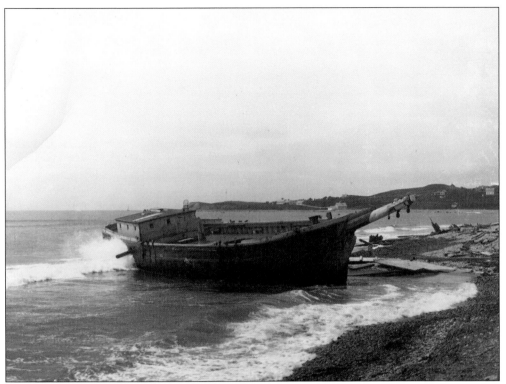

THE SCHOONER *MARIE ADELAIDE*, EARLY 1900S. Heavy seas have accounted for another wreck on Cuttyhunk's shores. The *Marie Adelaide* carried a cargo of lumber. (Courtesy New Bedford Whaling Museum.)

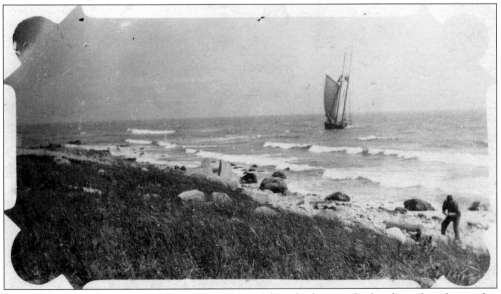

THE SCHOONER *JULIA AND MARTHA*, 1911. Although the seas look relatively calm in this view, the ship foundered on the treacherous rocks and reefs that abound along Cuttyhunk's shores. The men aboard were rescued by the revenue cutter *Acushnet*, but the *Julia and Martha* was declared a total loss.

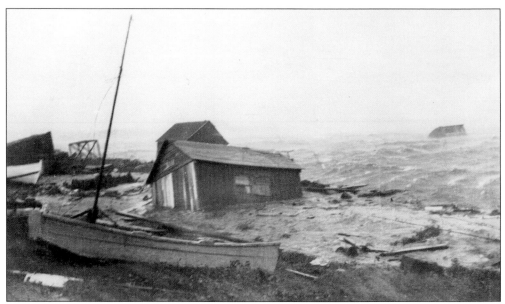

THE HURRICANE OF SEPTEMBER 21, 1938. Unlike the storms that hit today, the Hurricane of 1938 drove in without warning. Island houses are usually well prepared for the strong winds of nor'easters, but the harbor and the small buildings clustered around it were, and still are, often vulnerable to the high seas that sweep in.

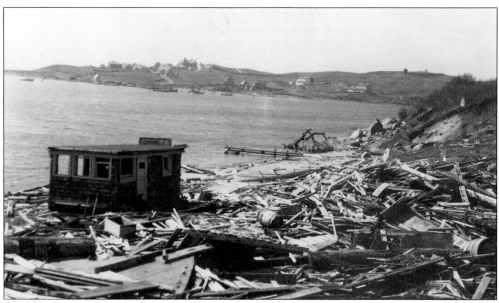

COPICUT NECK AFTER THE STORM, 1938. Piles of wreckage filled the shore on Copicut Neck after the hurricane subsided. Despite the violence of the storm, there was no loss of life on the island. In this view, a small shack (probably from the Point) has been left upright and relatively unscathed.

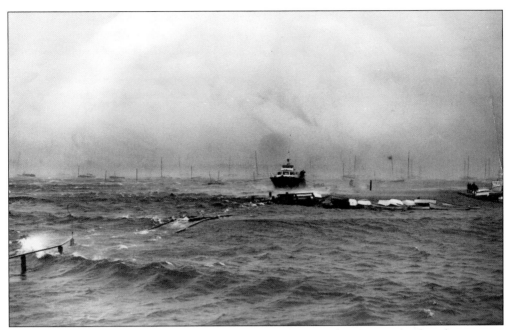

HURRICANE CAROL, AUGUST 31, 1954. The Hurricane of 1938 struck after the summer season was over, but Hurricane Carol hit in August while yachtsmen were still vacationing on their boats. Many boats dragged their anchors and were washed ashore, as was this raft of rowboats. (Photograph by Norman Fortier.)

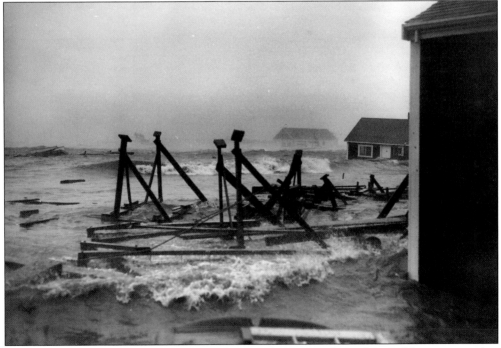

THE HARBOR, AUGUST 31, 1954. This photograph captures the violence of the storm in what is normally a calm and sheltered harbor. The houses that are already afloat are among several that washed up across the harbor on Copicut Neck. (Photograph by Norman Fortier.)

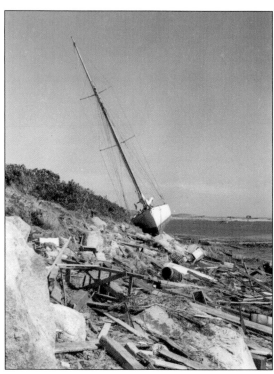

BEACHED AMID THE RUBBLE, 1954. A sloop lies tilted against the shore of Copicut Neck, where several others suffered the same fate. Some boat owners rode out the hurricane aboard, but others came ashore and stayed the night with island families or in the town hall. During the storm, high seas swept across the beach that leads to Copicut Neck, making it temporarily another island.

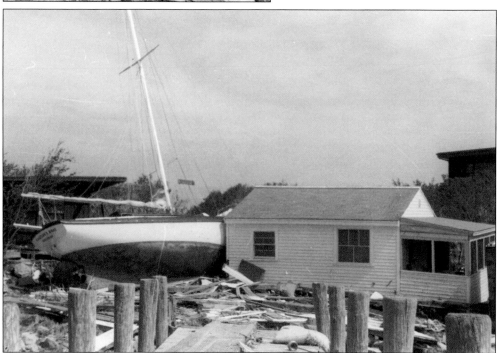

UNUSUAL NEIGHBORS, 1954. Before Hurricane Carol swept it over to Copicut Neck, the small white cottage on the right was located on a low-lying point of land near the Fish Dock. After it was floated back and repositioned at the Point, Charles Tilton Sr. summered there for several years.

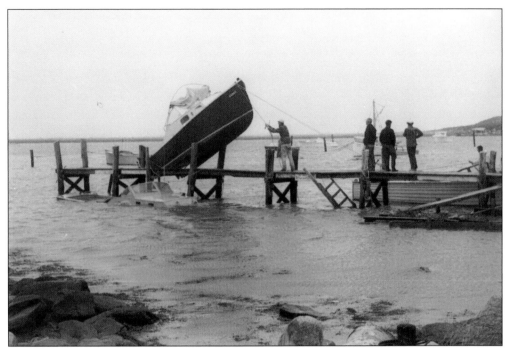

GROUNDED AT THE FISH DOCK, 1954. Island men consider the problem of a boat now firmly wedged among the pilings at the Fish Dock. Because the storm hit at high tide, harbor waters rose to extreme heights. Workmen were later able to refloat the boat by sawing off a piling.

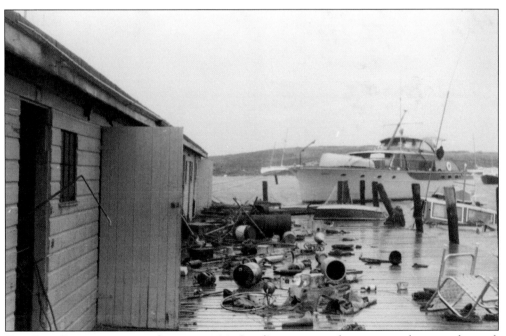

THE FISH DOCK AFTER THE STORM, 1954. Carol's storm-tossed waves rose almost to the roofs of the buildings along the Fish Dock. Many boats belonging to guides and lobstermen were damaged or lost, and much of their gear was swept away.

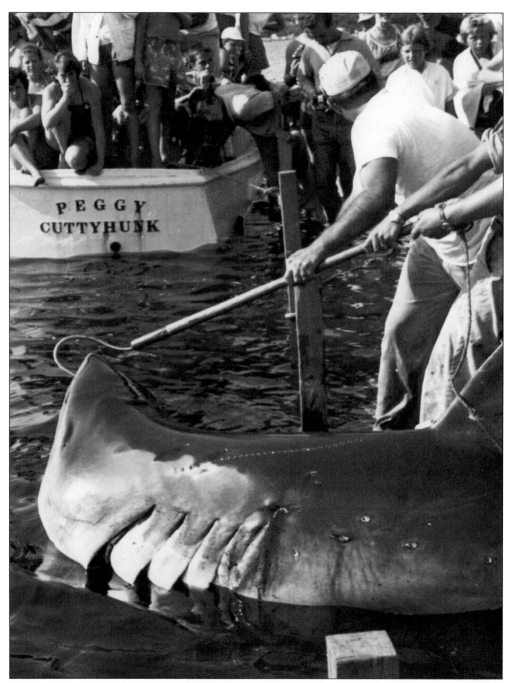

A Near Disaster, August 7, 1954. The appearance of a great white shark in the harbor caused tremendous excitement on the island. With many people crowded aboard his boat, Charles Tilton Sr. and his son Charlie (both well-known island guides) were the ones who successfully harpooned the shark and brought it to the dock after a three-hour battle. The shark was an impressive 13 feet 7 inches long. As the island scales were not equipped to register its great weight, it was estimated at between 1,300 and 1,800 pounds. Needless to say, swimmers were reluctant to venture too far out into the surf for the rest of the summer.

Seven

LIFE IN WINTER

Early island life was simple and rugged, with almost no luxuries. Families had to rely on outhouses; natural springs, wells, rain barrels, and cisterns for water; candles, oil lamps, or lanterns for lighting; and wood, coal, or kerosene for cooking and heating. Foot warmers heated on the stove were tucked into beds at night. The upstairs was icy cold, and there were tales of children freezing to death during the night. Some enterprising men salvaged coal from wrecked ships to bolster their supplies.

Chilling winds and ice storms kept the fishermen ashore, and work turned to repairing boats, mending nets, and building lobster traps. Ice, the winter commodity, needed to be cut and hauled to the icehouses for storage until the warmer months. Eel fishing in the ice-covered harbor brought some fresh seafood to the table to supplement food preserved by smoking, salting, or storing in root cellars.

The lighthouse keeper continued his solitary vigil through the stark winter months, as shipwrecks were common with unpredictable storms and seas. In 1889, when David Bosworth was captain of the newly established U.S. Life-Saving Service on Cuttyhunk, his crew made a famous rescue of the *Victor* on a night so cold that ice formed on the oars of the rescue boat at every stroke.

In 1850, just over 30 people were listed in the town census. Today, about 40 people live on Cuttyhunk year round. It still takes a hearty soul to survive the blustery winters of Buzzards Bay and Vineyard Sound.

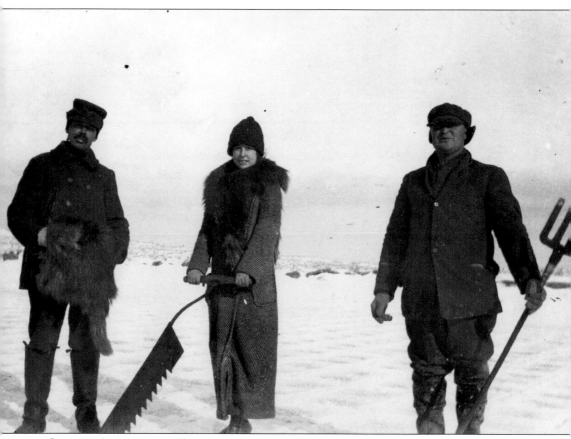

CUTTING ICE WITH THE TOOLS OF THE TRADE, 1916. When the Cuttyhunk Fishing Club was established in 1864, islanders diked the Wash Pond so the fresh water would flow in and freeze. The ice was harvested in blocks. The nearby West End Pond remained tidal. Men were paid $1 an hour to saw ice into blocks, which were stored in the three icehouses. There were two big icehouses near the Wash Pond and a smaller one at the club. In this photograph, Marion Smith holds the saw for cutting the ice, and Tom Dowling holds the fork for prying the blocks apart. The man with the fur muff is unidentified.

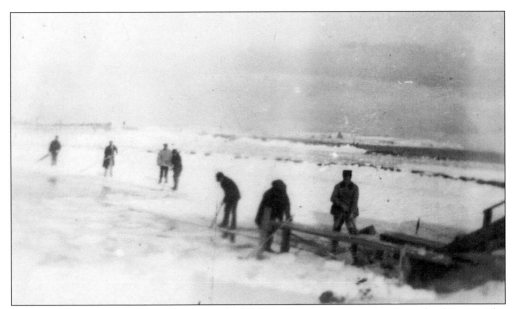

CUTTING ICE ON THE WASH POND, C. 1916. Islanders bundled up for the task of cutting the thick ice into blocks. Ice was stored in the icehouses, which were insulated with hay. The ice was later delivered to iceboxes at the fishing club and island homes. Ice was also cut at the club's freshwater pond.

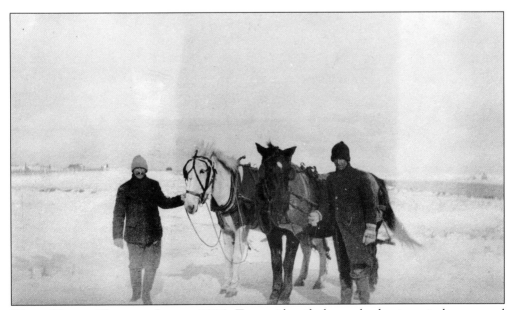

WORK HORSES HAULING ICE, C. 1915. Two unidentified men lead a team in harness and blankets. The horses eased the work of hauling ice to the icehouses for storage or for delivery to the club and residences.

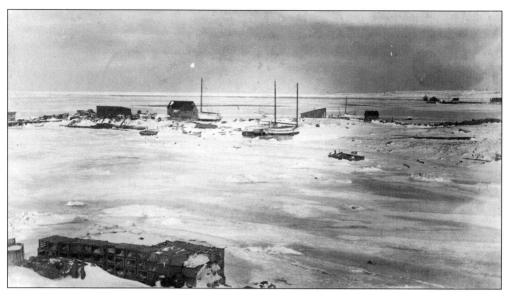

A Snowscape of Cuttyhunk Harbor, c. 1920. All activity ceases after a winter nor'easter. The lobster traps in the foreground are stacked on Joe Slate's Island. The Point (today's Fish Dock area) is in midground. In the distance are fisherman storage sheds and the lifesaving boathouse at the Narrows.

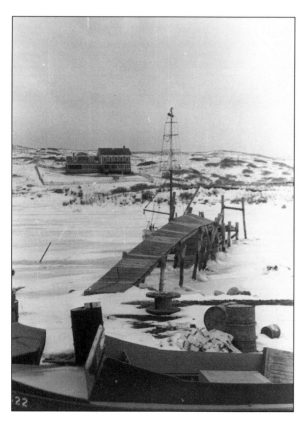

Ice Heaves the Pier, Early 1900s. A winter storm has buckled the pier opposite Joe Slate's Island. Mr. Shepherd built the dock to tie up his boat. In the background is Island Lodge, owned by the Beatty family, who served shore dinners in the warmer months.

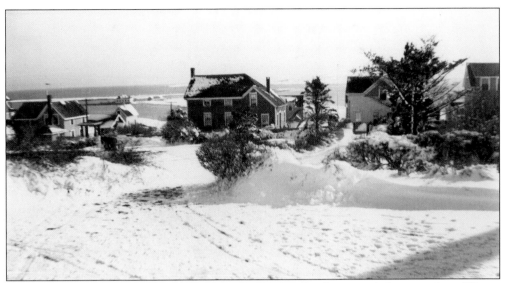

A SNOWY PATH FROM WINTER HOUSE, 1941. As one walks toward the town from Winter House, the houses on Broadway come into view. From left to right are the Roland Snow house, the Josiah Tilton house, the Keeney house, and part of the Ramos house. The newly constructed Coast Guard boathouse is in the distance at the Narrows.

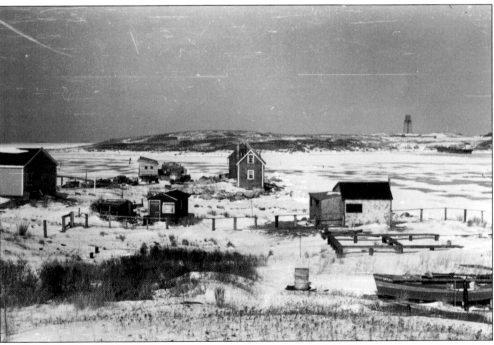

A WINTER SCENE LOOKING TOWARD THE POINT, C. 1950. This view was changed by Hurricane Carol in 1954. The buildings are, from left to right, John B. Cornell's house, the flat-roofed Fish Dock with two windows, the Dave Jenkins house, the Bangs cottages (built in 1939), and Bruce Newton's house. The foundation for the Thoresen house is in the foreground. The water tank and barracks were built on Copicut Neck during World War II.

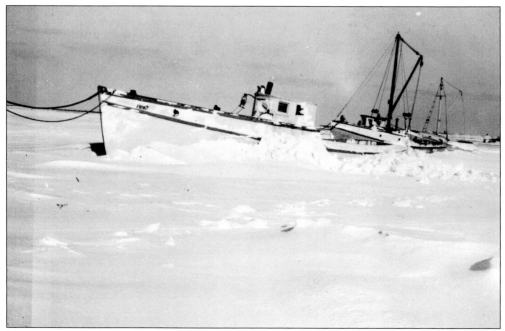

FISHING BOATS AGROUND IN SNOW AND ICE, C. 1915. *Somar*, a fishing boat belonging to Louis Ramos, awaits the spring thaw, which is still a few months away. Louis was one of five men later awarded the Congressional Life-Saving Medal for bravery in the rescue of the bark *Wanderer* in 1924.

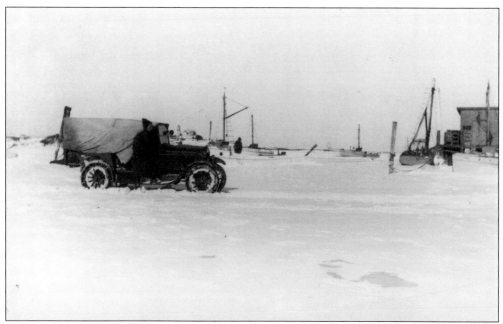

A SPECIAL DELIVERY, C. 1940. An island truck tries to navigate the snow to get to the Point. The cargo is covered with a canvas tarp, and the chains on the tires may help the steep climb up Broadway.

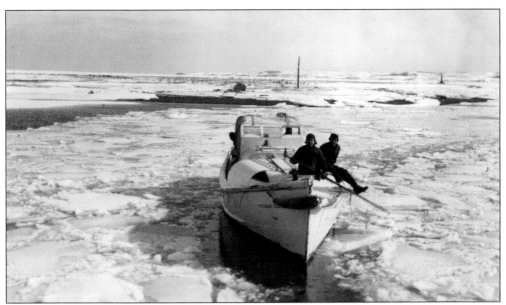

COAST GUARD WINTER DUTY, C. 1942. In this photograph (taken during World War II), a 36-foot motor lifeboat breaks through the ice to return to the boathouse. When the outer harbor froze, the Coast Guard would send an ice cutter from Woods Hole to open it up so the ferry could make its run. Although the guardsmen endured some icy weather, their relations with islanders were warm and friendly. According to Eleanor Snow Prell, "the fishermen often kept the men supplied with lobster and Mrs. Snow would spoil them with an occasional pie."

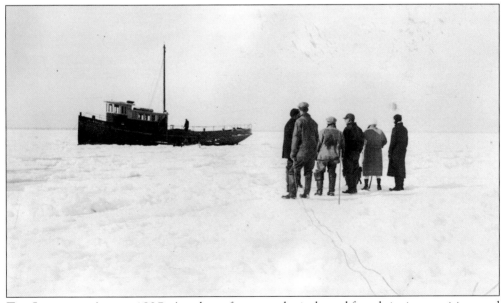

THE ICEBOUND ALERT, 1937. A stalwart few meet the icebound ferry bringing provisions and mail. Note the rope lines, used to pull a skiff back and forth across the ice to unload freight. Today, the ferry makes deliveries to the island only once a week during the winter, and that trip is often canceled due to bad weather.

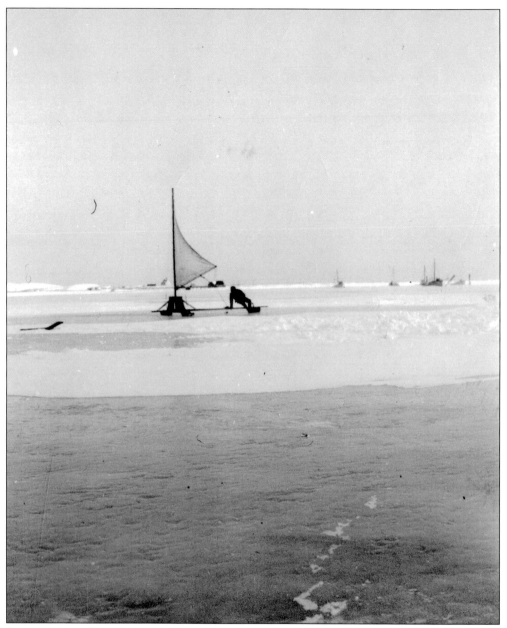

ICEBOATING IN FINE FORM, C. 1918. Men, young and old alike, used iceboats for competitive racing or for eel fishing. This iceboat shows the extended platform designed for balance in tacking against a winter northeastern blow. In a strong wind, the low resistance from the ice must have almost enabled them to fly.

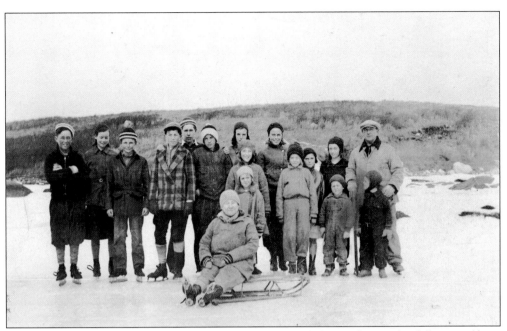

ICE-SKATING OFF COPICUT NECK, 1934. Pictured from left to right are the following: (front row) Etta King (on the sled); (middle row) Eleanor Snow, Annette Stetson (behind Eleanor), unidentified, Johnny Stubbs, and Jimmy Pullen; (back row) Herbert Stetson, Barbara MacKay, Donald MacKay, Carlton Veeder, Alpheus Tilton, Wilfred Tilton, Hazel MacKay, Gladys Snow, Mildred Allen, Doris Tilton, and ? Cleaves.

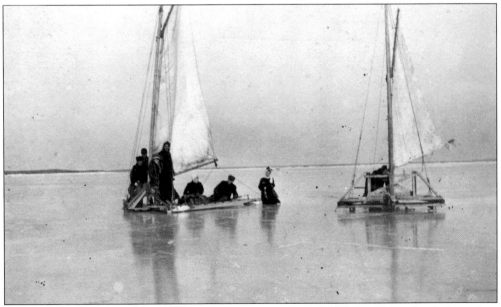

ICEBOATING ON CUTTYHUNK POND, 1918. Islanders removed the gaff-rigged sails from their catboats and transferred them to homemade wood platforms for iceboating. The competitive sport must have been a thrilling diversion during the winter months.

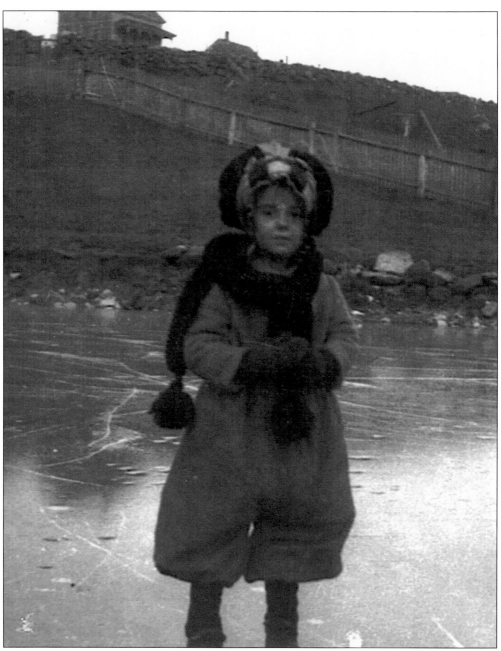

Marjorie Snow Reeves Ice-Skating, 1917. Marjorie grew up on Cuttyhunk and graduated from the one-room schoolhouse. Her father, Roland Snow, was stationed on the island with the Coast Guard. She recalled a Christmas at the house of her grandparents Elizabeth and David Bosworth. The tree had miniature candles and, underneath, a red Dutch-style sled from Santa. She learned to skate with "double runners" on the Cuttyhunk Fishing Club pond and later glided in "single-blade shoe skates" on the West End Pond.

Eight

RECREATIONS, TRADITIONS, AND CELEBRATIONS

Cuttyhunk, while remote and set apart from the mainland, is characterized by a close cluster of cottages at one end of an island only three quarters of a mile wide and two and a half miles long. Neighbors see each other daily, shopping at the island store, meeting the ferry, picking up the mail at the post office, and working at the Fish Dock. On an island where people can walk everywhere, communication is easy. One can call from the front porch to a passing friend, smell a neighbor's baking bread, and know by the ringing of the schoolhouse bell that the kids are on the way home.

Marjorie Snow Reeves tells of island life during the 1920s. Spring was a time for roller-skating on the concrete sidewalks William Wood installed. Many had a garden to grow fresh flowers and vegetables for their families and the boardinghouses. On May Day, the children secretly hung flower baskets on the neighbors' doors. In the summer, there were picnics on the beach, fishing expeditions, and fireworks. In the fall, on the way home from school, kids stopped by the store for penny candy. Halloween pranks involved tying loose objects to the flagpoles. Thanksgiving dinner included fresh cranberries from the bog at the West End. Puzzles were often the evening's entertainment before being tucked in feather beds. Saturday night was bath night, with everyone sharing the same water. Mother was last.

Islanders pace life by the cycles of the sun and moon, the direction of the wind, and changes in the seas. Recreations, traditions, and celebrations ebb and flow with the seasons and have changed little over the years. These shared experiences continue to join one generation to the next in a lasting legacy.

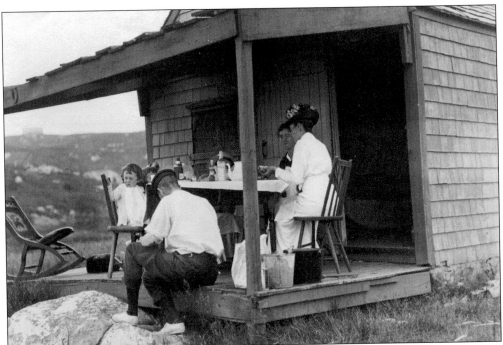

DINING ON THE PORCH OF THE SLOCUM COTTAGE, 1918. Although this appears to be an informal lunch or tea party, at the time it was considered proper to wear one's hat. The child has a cloth napkin tucked in at the neck, and the table is set with sandwiches, a china teapot, and a bottle of spirits.

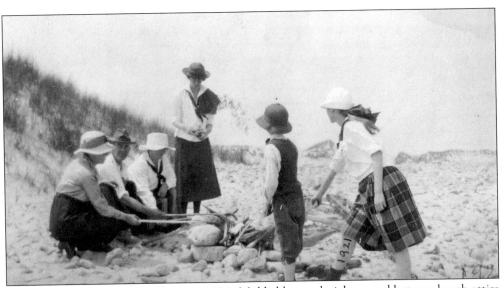

A HOT DOG ROAST AT THE BEACH, 1921. Middy blouses, knickers, and hats are beach attire of the day as the Ames-Slocum family roasts hot dogs over an open fire. Hot dog roasts continue to be a favorite summer event.

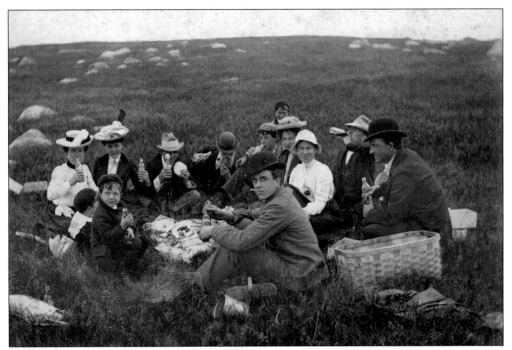

A FAMILY PICNIC, 1909. George and Etta King and other Akin family members are picnicking on a rocky hillside of Cuttyhunk. The joker in the family balances a hardboiled egg on his soda bottle. Etta was the oldest of the Akin orphans. After marrying George, she raised her six siblings—Eva, Alva, Ralph, Ruth, Cora, and Orin.

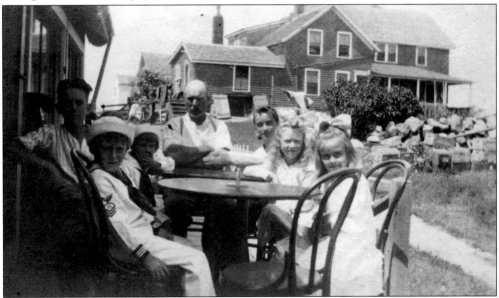

A BIRTHDAY PARTY AT THE CASINO, 1919. Marjorie Snow Reeves (far right) celebrates her seventh birthday with an ice-cream party hosted by her uncle Frank Veeder. The others, from left to right, are David Bosworth III, Irwin Winslow "Coot" Hall, Lloyd Bosworth, Frank Veeder, Madeline Jamieson, and Dorothy Hall. The Bosworth House is in the background. The Casino was later known as Gram Veeder's.

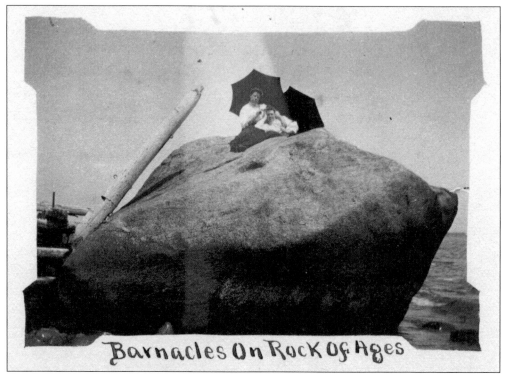

Barnacles On Rock Of Ages

BARNACLES ON ROCK OF AGES, C. 1910. Two young ladies pose seductively on a large rock along the shore. One wonders how they managed to shimmy up there in long skirts, ruffled blouses, and parasols. They certainly reflect the saying "Ladies never sweat, my dear. They just glow."

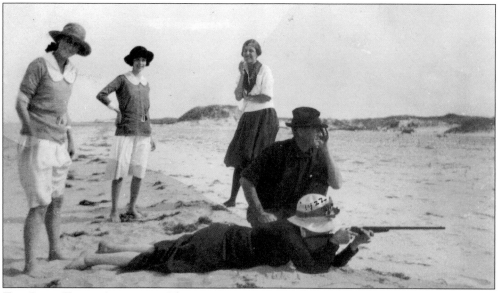

THE LADY TAKES AIM, 1922. The 1920s were roaring on Cuttyhunk as the ladies of the day were not afraid to bare a leg or shoot a shotgun. Of course, a flowered hat made the activity more respectable.

94

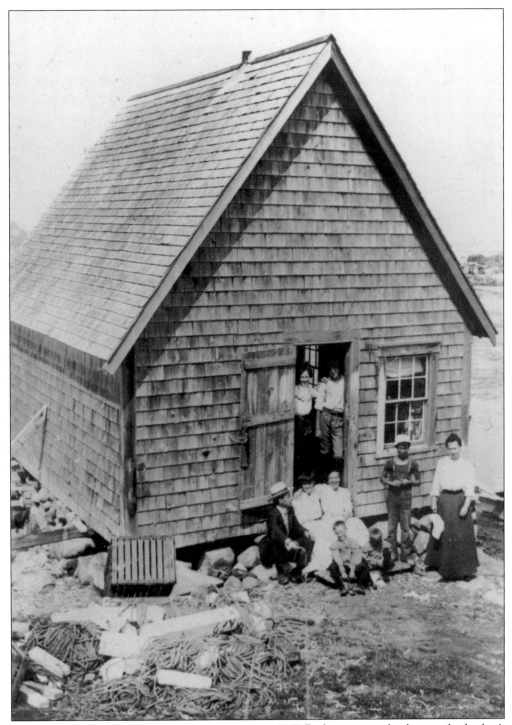

THE AKIN FAMILY IN FRONT OF OVEREDGE, C. 1905. Built precariously close to the harbor's edge, Overedge was the studio for Cora Akin Doubleday. She painted island scenes on clam shells. Later, George King and Harold Dean used the building for a lobstering business. Overedge was swept away in the Hurricane of 1938.

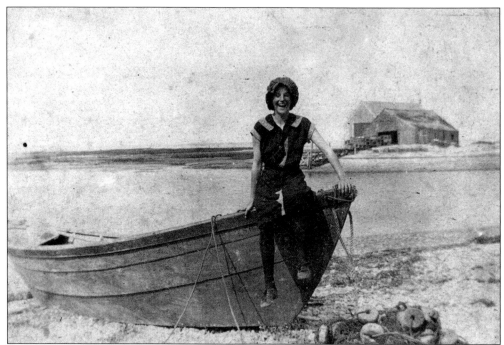

A GIRL PERCHED ON THE BOW OF A DORY, EARLY 1900S. This unidentified girl shares her laughter while posing on a dory at the Narrows. In the background is a lifesaving boathouse with tracks for launching lifeboats. These structures later washed away in the Hurricane of 1938. In the foreground is a heap of fishing nets with cork floats.

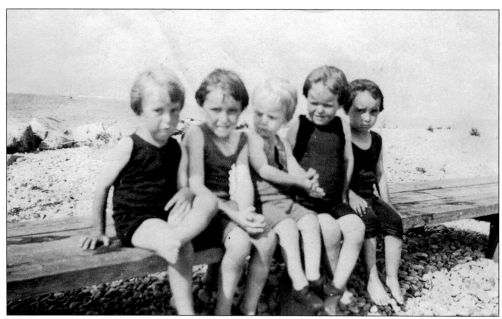

CUTTYHUNK SUMMER PLAYMATES, 1924. Little tykes in cotton tank suits pose at the beach. From left to right are Hazel MacKay, Betty Smith, Donald MacKay, Barbara MacKay, and Dot Smith.

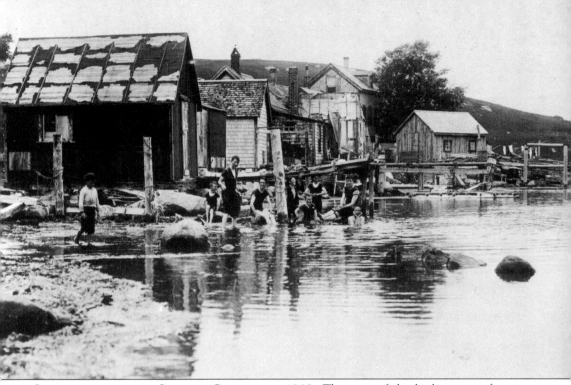

SWIMMING NEAR THE CORNELL COMPOUND, 1903. This area of the harbor was a favorite gathering spot. Children in knit knee-length swim suits splashed in front of the fishermen's storage sheds and houses. At one time, this was the deepest part of the harbor. After the basin and channel were dredged and the fill was deposited here, this area turned into a tidal flat. Then, the Hurricane of 1938 washed away most of the sheds and houses.

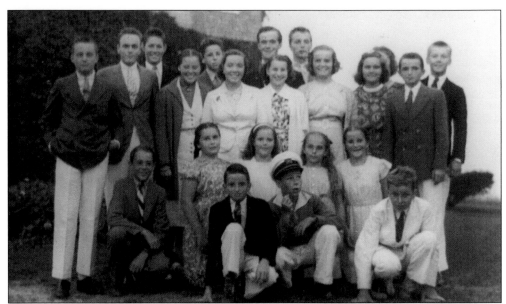

THE ANNUAL CUTTYHUNK YACHT CLUB BANQUET AT WINTER HOUSE, 1938. At summer's end, yacht clubbers gather for awards, sing the traditional club song, and pose for a group photograph. From left to right are the following: (first row, kneeling) Frederick Pabst Goodrich Jr., Harry Kidder, Thatcher Tucker Thurston, and James Bush House; (second row) Virginia Thurston Coope, Sarah Garfield Smith, Martha Goodrich Goldman, and Peggy Middleton Hall; (third row) Timothy Prescott House, Cornelius Ayer Wood Jr., Flora Hall Lovell, unidentified, unidentified, Flora House Fairchild, Oriel Wood Ponzecchi, and George Kidder; (fourth row) Newell Garfield Jr., Elliott Ladd Thurston, James B. Hall, Francis B. House III, Josephine Howell Kidder Shane (partially seen), and Wyatt Garfield.

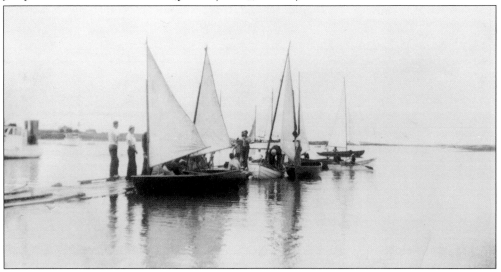

THE CUTTYHUNK YACHT CLUB SETS SAIL, 1938. Over the years, youngsters have learned to tie a bowline knot, set a sail, and steer a straight course through summer yacht club instruction. This appears to be the advanced group getting ready for an afternoon of racing. World War II put an end to the early yacht club, but it resumed in 1955, when children of early members returned to summer on Cuttyhunk.

CUTTYHUNK BEAUTIES EYE MUSCLED DONALD MACKAY, C. 1939. On his rounds of dropping off freight and ice brought over on the ferry *Alert*, Donald MacKay takes a break to hug Mildred Allen while Marjorie Fears (left), Annette Stetson (center), and Sallie Tilton look on. A little brother keeps his distance; the girl standing is unidentified. In the background is the Coast Guard boathouse, built the same year.

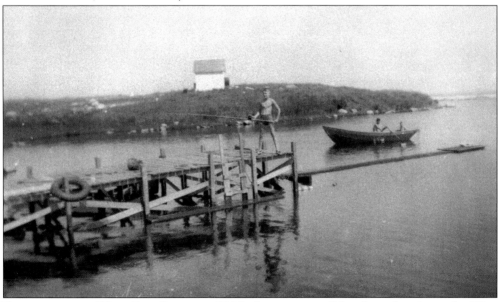

FISHING AT THE WEST END POND, C. 1944. A young man fishes from the pier at the West End Pond. In the background, two boys row a dory toward the Cuttyhunk Lighthouse, which was taken down in 1947, along with the pier.

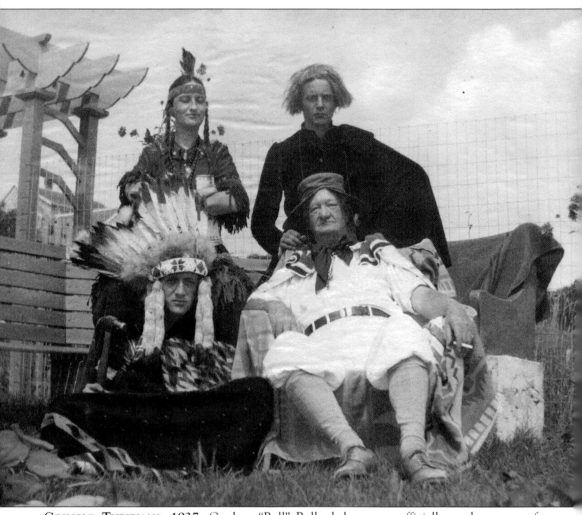

GOSNOLD THESPIANS, 1937. Gardner "Bull" Bullard, known unofficially as the mayor of Cuttyhunk, wrote a witty play on Gosnold's discovery of Cuttyhunk. It was performed at the town hall for the 335th anniversary. Known for encouraging the arts and drama on island, he also presided over a minstrel show and summer theater. From left to right are the following: (front row) Bert Kelsey (Wampanoag Chief) and Gardner Bullard (Second Officer Gilbert); (back row) Madeline Jamieson Bancroft (Wampanoag maiden) and Frank House (Commander Bartholomew Gosnold).

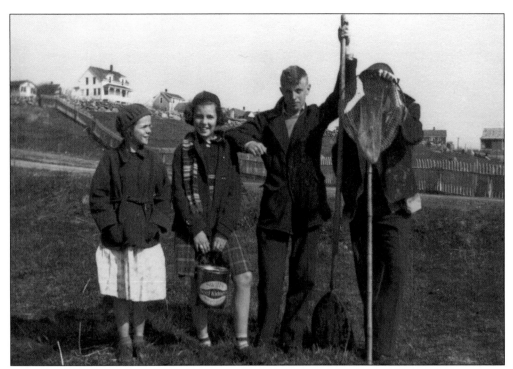

A Fishing Expedition, 1938. Pausing with their long-handled nets are, from left to right, Ethel Stubbs, Joan Veeder, Wilfred Tilton, and "Junior" Harrington. Joan Veeder holds a can that reads, "Swifts Beef Kidneys," perhaps the dinner fare alternative if fish are elusive.

A Farewell Bouquet for Mildred, 1937. The send-off traditions at the island ferry range from streamers and leaps off the dock to farewell bouquets. None was quite so elaborate as Mildred Allen's bouquet of native flowers, leaves, a can, a sneaker, a wine bottle, and a horseshoe crab. Bouquets often included shells, driftwood, or messages from friends tied on with ribbon streamers.

In a Big Hurry to Go Nowhere, c. 1940. These people seem to think this vehicle can run on will alone or is at least worth its value in amusement. With only a mile and a half of paved road on the island, cars and trucks have been primarily for providing services rather than private transportation. This vehicle seems to have run its wheels off dodging ruts on the unpaved roads and finally has come to a halt near the King-DeArmond home.

Nine

PENIKESE

Penikese Island, one mile north of Cuttyhunk, has had the most varied history of all the Elizabeth Islands. Native Americans hunted and fished there. In 1602, Bartholomew Gosnold visited the island. Various owners timbered, fished, farmed, and raised sheep and turkeys. In 1873, Louis Agassiz established the Anderson School of Natural History. This school for naturalist teachers was open only two years and was the forerunner of the Marine Biological Laboratory at Woods Hole. The state-of-the-art facility was mostly destroyed by fire in 1895.

The State of Massachusetts built a leprosarium there in 1904. The first superintendent, Dr. Lewis Edmonds, was followed in 1905 by Dr. Frank Parker, a specialist in skin diseases. For the next 16 years, Parker and his wife, Marion, treated and cared for Massachusetts residents who were afflicted with leprosy, later known as Hansen's disease. A hospital, cottages for the patients, a laundry, and water reservoirs were built on the windward side of the island. The Parkers went to great lengths to make the patients' lives comfortable. Fourteen patients are buried in the island cemetery. In 1921, the hospital closed and the remaining patients were moved to the national leprosarium in Carville, Louisiana.

In 1924, Penikese was designated a state bird sanctuary and a rabbit-propagation site, managed by the Massachusetts Department of Conservation, Division of Fisheries and Game. In order to restore the island to a more natural condition, all structures and machinery that the caretaker did not need were destroyed. At the beginning of World War II, because of military activity in the area and concerns for the caretaker, all projects were abandoned or relocated. The island eventually became the home of the Penikese Island School, founded in 1973 by George Cadwalader. The school was designed to provide an alternative program for delinquent boys age 13 to 18 and continues today. The island remains a bird sanctuary under the Massachusetts Division of Fisheries and Wildlife and is a Massachusetts Historical Site.

THE JOHN ANDERSON HOUSE, 1867. John Anderson, a wealthy New York merchant, purchased Penikese Island and built this house, where he and his wife vacationed until 1873. They then donated the house and land to Louis Agassiz of Harvard University so he could open a school of natural history. Agassiz and some of the professors lived in the house during the school term. In 1904, the building became the year-round residence of the Penikese Island Leper Colony superintendent and, in 1912, was destroyed by fire. (Courtesy Marine Biological Laboratory Archives.)

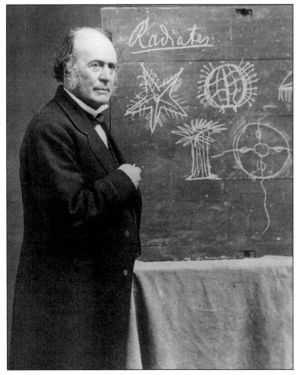

LOUIS AGASSIZ (1807–1873). Louis Agassiz was a highly honored naturalist from Switzerland who, among many achievements, developed the glacial theory. After a highly successful lecture tour in the United States, he was appointed chairman of Harvard University's Geology and Zoology Department. In 1873, he opened the John Anderson School of Natural History on Penikese, the first school to study nature in its own setting. (Courtesy Marine Biological Laboratory Archives.)

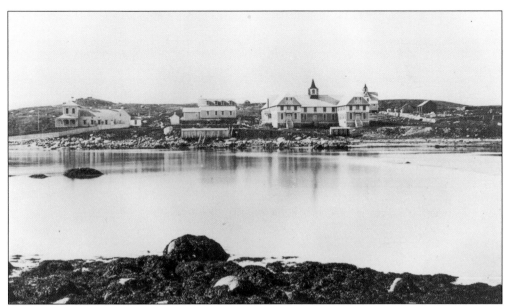

THE JOHN ANDERSON SCHOOL OF NATURAL HISTORY, 1890. The elaborate Anderson School of Natural History was built on the island of Penikese in 1873 and was open only for two summer sessions. Classes were informal, with students roaming the beaches and dredging the harbor for marine specimens. The first students numbered 16 women and 28 men from 11 states. Pictured here are the Anderson home (left) and the dining hall. In the large building, the first floor included workrooms and laboratories. The second floor was a dormitory. (Courtesy Marine Biological Laboratory Archives.)

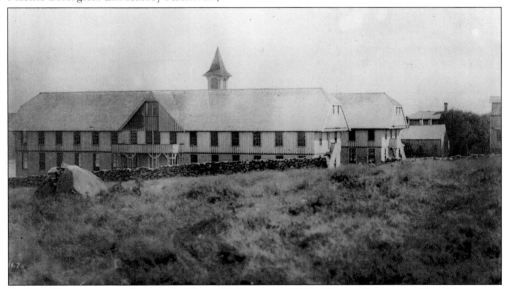

A SIDE VIEW OF THE SCHOOL'S MAIN BUILDING, 1890. The students considered it a great honor to learn from Louis Agassiz, his son Alexander, and the many other important scientists who taught here. Each wing of the elaborate H-shaped building was 120 feet long and 25 feet wide, joined in the middle by a 50-foot lecture hall. In the background (rarely seen in any photograph) is the small building that appears to have two chimneys. Dating from the early 18th century, it was once a farmhouse. (Courtesy Marine Biological Laboratory Archives.)

THE LEPER COTTAGES, 1905. The residences for the patients were located on the bleak southwestern side of the island. Each cottage housed two people comfortably, with two bedrooms, a kitchen, and a living room. Later, as the population increased, some patients lived in the new hospital building. Records from 1915 show that there were 30 patients (representing 11 different nationalities) on Penikese: 23 male, 6 female, and 1 unnamed. (Courtesy Hilary Bamford.)

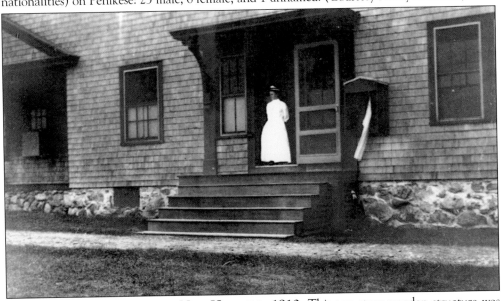

THE FRONT ENTRANCE TO THE NEW HOSPITAL, 1910. This two-story wooden structure was erected between two of the cottages, connecting them so that the complex measured 70 feet long and 45 feet wide. Note the outline of a cottage on the left. In the building were bedrooms for the sicker patients, a treatment room, a reading room, an amusement area, a kitchen, and a dining hall. There were also living quarters for a full-time nurse. With this new hospital, the island status was changed from a leper colony to a respected leprosarium. (Courtesy I. Thomas Buckley.)

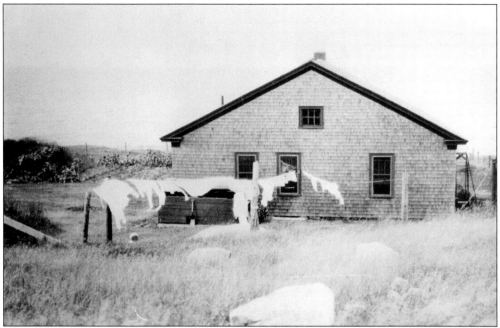

SUN-DRIED LAUNDRY, C. 1910. Patients Lucy Peterson and Isabel Barros resided in this cottage separate from the men. It appears they also decided to do their own laundry rather than use the laundry services of patients Yee Toy and Goon Lee Dip. The backside of the shingled house, situated on the southwest side of the island, shows their laundry line and coalbin. The unique variety of blackberries on the left still remains today.

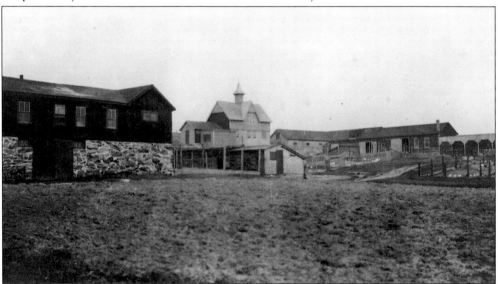

THE PENIKESE ISLAND LEPROSARIUM, C. 1910. The large barn in the background was originally built by Anderson c. 1868, rebuilt by the Anderson School, and later used by the leper colony. Buildings on the left housed visitors and workmen. The smaller buildings were used by the island farm, which supplied most of the food for the residents. After the leprosarium closed, its buildings were abandoned for five years and were burned in 1926. (Courtesy I. Thomas Buckley.)

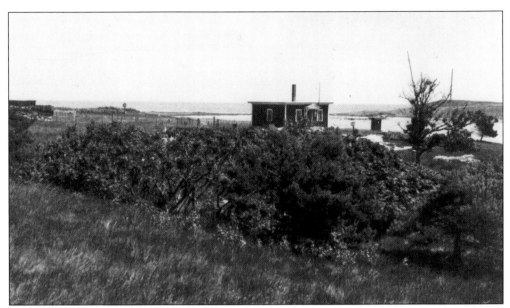

THE ESTABLISHMENT OF THE BIRD SANCTUARY, 1924. Under the state fish and game department, a bird sanctuary and rabbit-propagation station was established in 1924. Fred W. Wood, caretaker and warden, lived in this cottage, which had previously served as the laboratory of Dr. Frank Parker. The project was abandoned at the start of World War II because of concern over the safety of the caretaker and his family. It was the first time since the 1600s that Penikese did not have a resident. (Courtesy Massachusetts Division of Fisheries and Wildlife.)

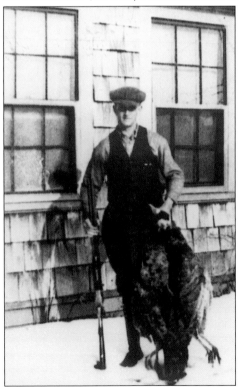

THE FIRST CARETAKER OF THE BIRD SANCTUARY, 1924. This photograph of Fred W. Wood with a wild goose was taken on Naushon before the beginning of his employment on Penikese. His service as caretaker required that his family live without telephones, neighbors, electric lights, gas, or even pets that might otherwise frighten the birds or other game. (Courtesy Massachusetts Division of Fisheries and Wildlife.)

Ten

NAUSHON, PASQUE, AND NASHAWENA

Naushon, Pasque, and Nashawena were acquired at different times by different members of the Forbes family, who now maintain them under separate trusts. Each has its own history and character, but all share a tradition of agricultural use by owners and tenants. Early tenants built their own houses, raised sheep and cattle, cut timber, produced salt, and grew cranberries and vegetables. Remains of their pasts exist on the islands in the many stone walls, a few cellar holes, and some old gravestones.

Naushon, the largest island, was owned from 1654 until 1843 by a succession of families with the familiar New England names of Mayhew, Winthrop, and Bowdoin. In 1843, John Murray Forbes bought the island with the Bowdoins' manager William Swain and, a few years later, became sole owner. After Forbes's death in 1898, Naushon was left in trust to his heirs. There are now about 20 houses. All but two are at the island's east end. An island landmark is the handsome lighthouse at Tarpaulin Cove.

Ownership of Pasque began c. 1680 under the recorded names of Wilcox, Mayhew, and Tucker. Lured by the splendid fishing in the surrounding waters, a group of New York and Philadelphia businessmen led by James Crosby Brown bought the island and, in 1866, founded the Pasque Island Club. Unlike the Cuttyhunk Fishing Club, it welcomed women. As well as a very old farmhouse, it included a large clubhouse, boathouse, icehouse, and a barn for horses and a cow. Forbes ownership started in 1939 and continues now with family use in the summer.

As with the other islands, Nashawena has seen many divisions of land and ownership, the principal owners being various members of the Slocum family. In 1905, Waldo and Edward Forbes acquired the island and built two cottages. The farmhouse, where the caretakers continue to live, is (like the one on Pasque) one of the oldest buildings in the area. Nashawena, with its farm and pastures, has most successfully retained its rural flavor, but the Forbes family has tried to maintain all three islands as much as possible in their original and undeveloped states.

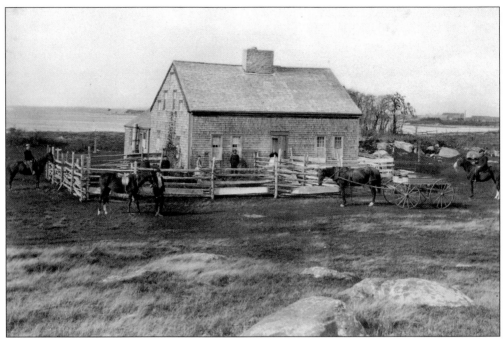

THE NONAMESSET FARMHOUSE. The oldest house on Naushon dates from the Revolutionary period. According to Seth Robinson (whose family was living there at that time), it was built c. 1760. It was then a small cottage with a great central chimney. In 1935, the house was restored and an ell was added on the east side. (Photograph by A.H. Folsom; courtesy Forbes family.)

THE NAUSHON FARMYARD, 1889. Most of these buildings are still in place, including the farmhouse and farm dining room and kitchen on the left. On the right are the meat house, the blacksmith and carpentry shops, and the old hay barn. Beyond the buildings and walled on both sides is the Farm Lane, heading west. (Photograph by A.H. Folsom; courtesy Forbes family.)

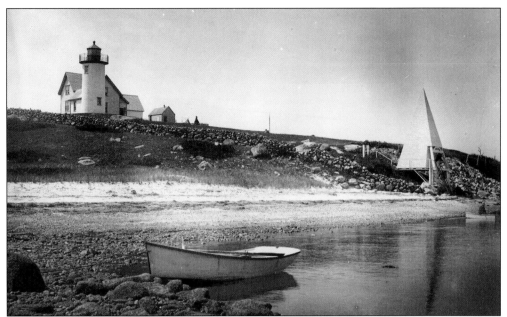

THE TARPAULIN COVE LIGHTHOUSE, 1896. Originally erected in 1759, this was the fourth lighthouse to be built on the southern New England coast. Zaccheus Lumbert of Nantucket built the lighthouse at his own expense, stating that it was "for the public good of the Whalemen and Coasters." The pyramidal structure on the beach held a bell used to warn ships away from the shore in foggy weather. (Photograph by Baldwin Coolidge; courtesy Society for the Preservation of New England Antiquities.)

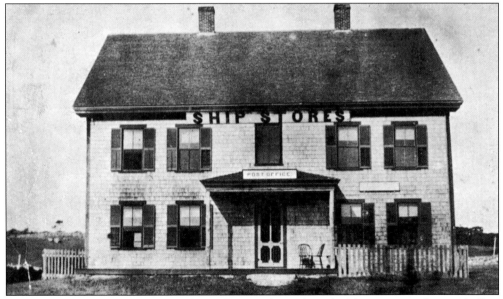

THE FARMHOUSE AT TARPAULIN COVE. During the 18th and 19th centuries, the steady flow of shipping traffic brought ships here for supplies. William Robinson, who lived there from 1898 to 1910, described the place in a letter as having "a Post Office sign over the front door, cages for letters on the store counter and shelves covered with canned goods, small wares, hard candy and a few groceries." (Postcard by Whitten & Dennison; courtesy Debbie Scanlon.)

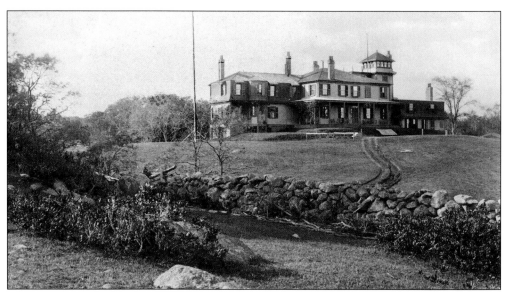

THE MANSION HOUSE, 1889. Built in 1809 by James Bowdoin, this house was originally a simple, square farmhouse. As time went by, additions were made to both ends and, for a period, it had an imposing tower, which was later removed. John Murray Forbes became the proprietor of Naushon in 1856 and subsequently brought up a family of six children in the Mansion House. His descendants continue to summer on the island. (Photograph by A.H. Folsom; courtesy Forbes family.)

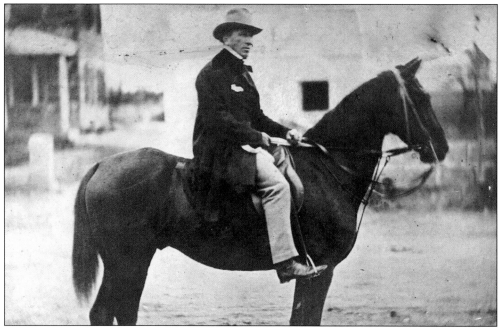

JOHN MURRAY FORBES, 1813–1898. Forbes began his career at age 13 as a cabin boy aboard a ship bound for China. He later established a profitable trade in tea and silks in the same country. Highly successful as a businessman, he also invested in railroads. He is known to have assisted the Underground Railroad and, during the Civil War, obtained loans to assist the North in financing its war needs. (Courtesy Forbes family.)

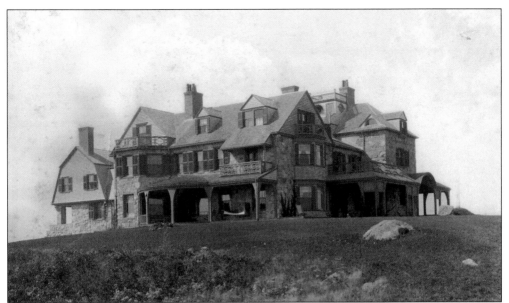

THE STONE HOUSE, 1889. William Ralph Emerson designed the largest house on Naushon in 1887 for William H. Forbes, son of John Murray Forbes. It is built of large stones taken from the shores and old stone walls on the island. It stands on a high ridge, with a view of Hadley Harbor and Buzzards Bay. (Photograph by A.H. Folsom; courtesy Forbes family.)

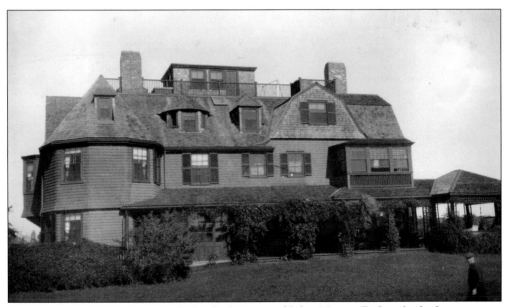

THE UNCATENA HOUSE. J. Malcolm Forbes, son of John Murray Forbes, built this imposing house in 1882. The old farmhouse, located just behind the big house, was built in 1809. It was later modified and used as dining room, kitchen, and servants' quarters. In 1890, the main house was greatly enlarged. (Courtesy Forbes family.)

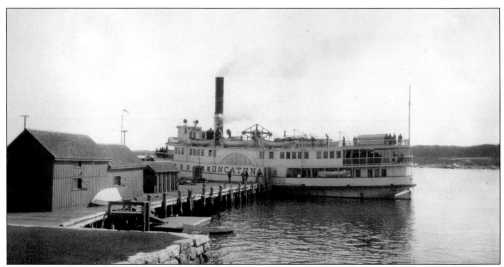

THE FERRY UNCATENA. The ferry, seen here docked in Uncatena Harbor, brought passengers from New Bedford and carried large amounts of luggage (as well as horses and other livestock) for the Forbes family. The harbor at Uncatena was one of several stops along the way before its final docking in Nantucket. (Courtesy Forbes family.)

THE WILD DUCK. J. Malcolm Forbes's handsome steel schooner *Wild Duck* was designed by Edward Burgess to work under both sail and steam. Its overall length was 154.5 feet, with a beam of 23 feet and a 7.5-foot draft. It was used for trips to Florida, the Caribbean, and northwest coast of South America. Its home port was Naushon from 1891 to 1899. (Courtesy Forbes family.)

THE YACHT *IDUNA*, 1897. The Forbes family used the 64-foot-long *Iduna* as a launch until the early 1940s. It is shown here tied up at the Upper Wharf in Hadley Harbor. (Photograph by Baldwin Coolidge; courtesy Woods Hole Historical Collection.)

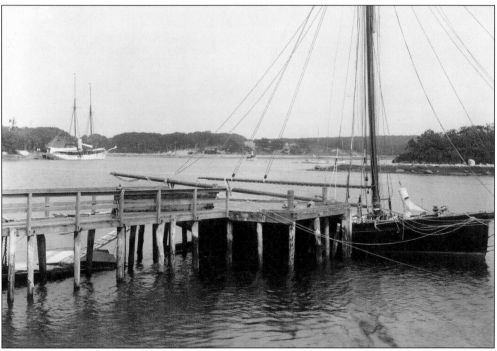

HADLEY HARBOR, 1897. J. Malcom Forbes's schooner *Wild Duck* appears in the background in this quiet Naushon harbor scene. Hadley Harbor has long been a popular stopover for yachtsmen. The boat tied up the at Bobolink Wharf is the cutter *Hesper*, owned by William Hathaway Forbes. (Photograph by Baldwin Coolidge; courtesy Woods Hole Historical Collection.)

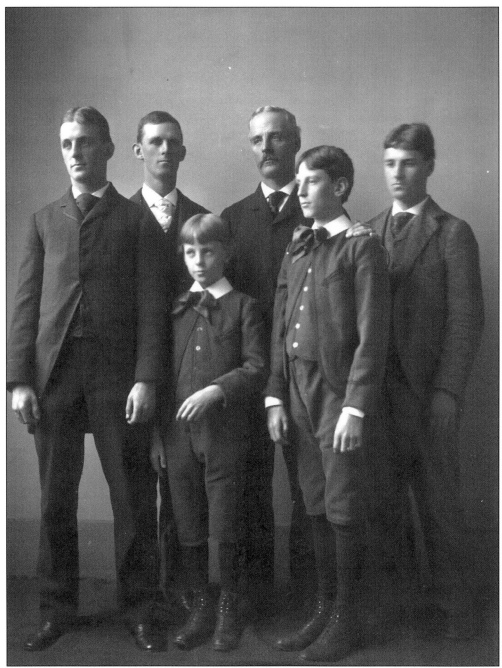

MEMBERS OF THE FORBES FAMILY, 1892. William Hathaway Forbes, son of John Murray Forbes, stands with his handsomely dressed sons. From left to right are the following: (front row) William Cameron Forbes, Alexander Forbes, and Waldo Emerson Forbes; (back row) Ralph Emerson Forbes, William Hathaway Forbes, and Edward Waldo Forbes. (Courtesy Forbes family.)

RIDERS READY TO GO, 1920. At that time, each house had its own stable and kept horses for members of the household to ride or drive, as this was the only method of transportation on the island, except for shank's mare. (Courtesy Forbes family.)

SETTING FORTH ON AN EXPEDITION. From two-wheel traps and single-seat Meadowbrooks to two-seaters, carriages of all sorts were used on Naushon. Ponies were sometimes hitched to a governess cart, or basket wagon—so called because its three-sided seat (woven with reeds) kept children from falling out. (Courtesy Forbes family.)

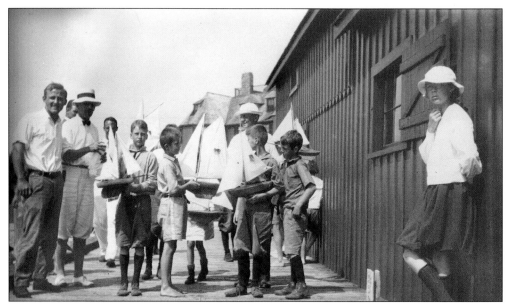

THE PROUD YACHTSMEN, 1920. Forbes children line up at the Upper Wharf before the annual model boat race. Families and friends stand on the Uncatena dock to cheer on the contestants. The races are still held, with the boat classes ranging from midget to giant. Included in the races are schooners, sloops, catamarans, or any rig dreamed up. (Courtesy Forbes family.)

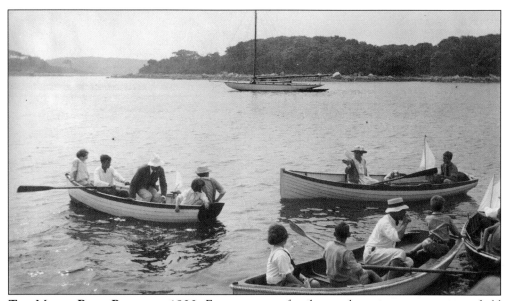

THE MODEL BOAT REGATTA, 1922. Every summer, family members rig a great variety of old models or build new ones to compete in what is known as the Bennet Yacht Club Regatta. The event takes place in the Outer Harbor of Uncatena, where handlers and skippers in rowboats line up to start their entries in the race. (Courtesy Forbes family.)

ALICE AND AMELIA FORBES, 1905. Fashions have changed considerably, but these decorously clad girls are ready to jump off the Uncatena dock and have their swim. (Courtesy Forbes family.)

A COLLECTION OF HATS. These guests are wonderfully arrayed for their visit and look quite prepared to enjoy themselves. (Courtesy Forbes family.)

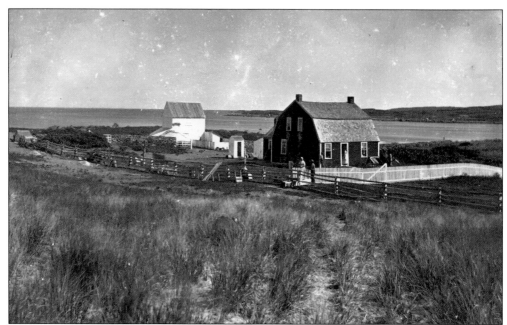

THE OLD FARMHOUSE ON PASQUE ISLAND. Although very little of the original structure remains, this house is said to be one of the two or three oldest houses in New England and was built in the early 1600s. The second building in the picture is a barn that housed cows and horses during the Pasque Island Club days.

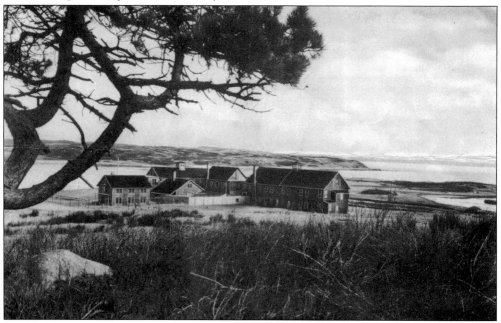

THE PASQUE ISLAND CLUB, 1918. Like the Cuttyhunk Fishing Club, the Pasque Island Club was well located for superb striped bass fishing. Unlike the former, however, it welcomed wives and children. Pasque had a long deepwater wharf where large boats could land. As a result, horses, wagons, and even such luxuries as pianos could be brought to the island. (Courtesy Debbie Scanlon.)

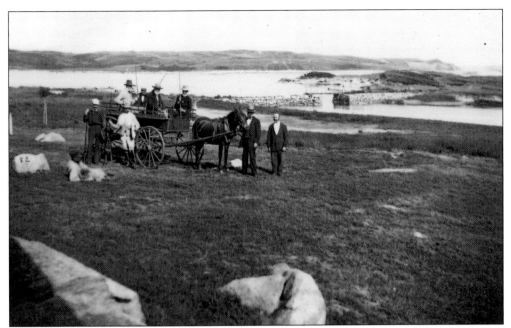

A FISHING EXPEDITION. Before setting off for a day of fishing, these unidentified men (probably club members) pose with their chummers. Chummers baited their hooks, helped land their catch, and perhaps offered advice. The men always fished from the shore, not from boats.

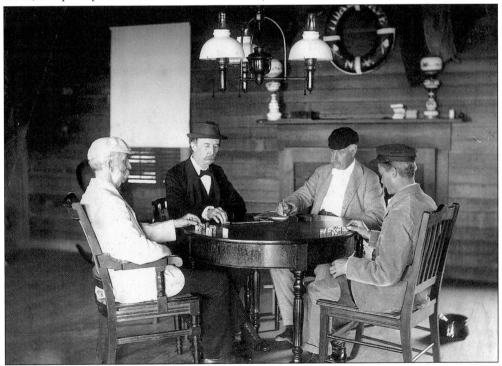

A GAME OF DOMINOES. The clubhouse also had a museum room with a few stuffed animals and sitting rooms for smoking and games such as cards or dominoes. Hats were apparently in order for the players, who appear to be taking the game very seriously. (Courtesy Pasque Trustees.)

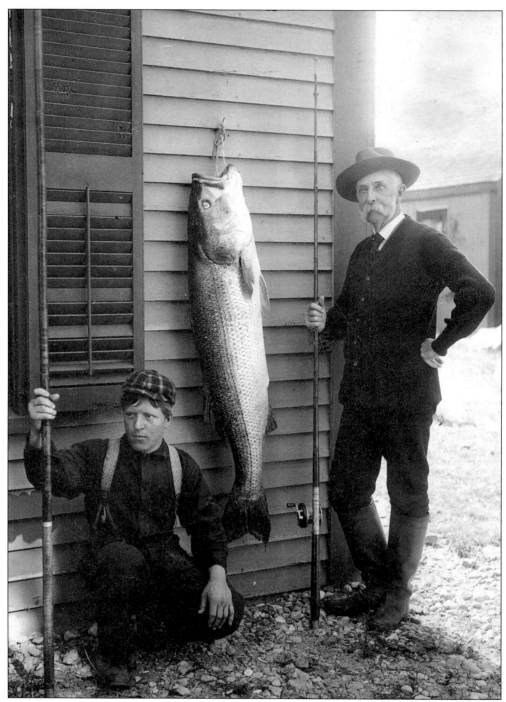

THE CATCH OF THE DAY, C. 1896. Pasque Island Club member A.F. Higgins displays an enormous striped bass while his young chummer crouches nearby. Although catching large numbers of bass this size was not unusual at the time, subsequent drops in the fish population was one reason for the dissolution of the club in 1923. (Courtesy Pasque Trustees.)

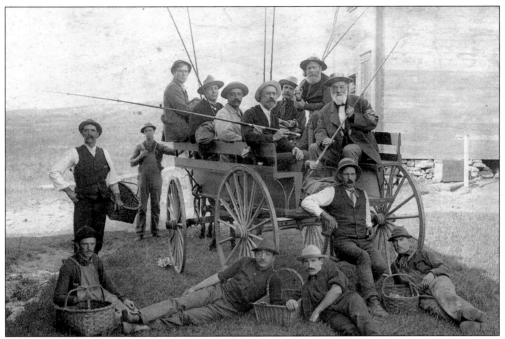

MEMBERS AND GUIDES SETTING FORTH. Club members, wearing jackets and some even with ties, hold fishing rods while their shirt-sleeved chummers pose on the ground with baskets. The wagon took the men to various fishing spots on the island. (Courtesy Pasque Trustees.)

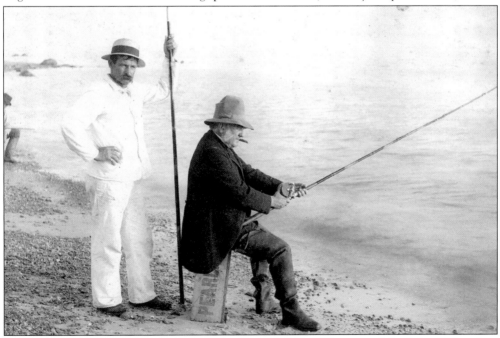

JOHN O'DONAHUE FISHING. While his chummer Gilbert Wilcox stands by, John O'Donahue sits comfortably on a box and waits for a bite. Although O'Donahue is wearing hip-length boots, his chummer will probably assist him in getting fish ashore and rebaiting his hook. (Courtesy Pasque Trustees.)

123

A PICNIC AT THE BEACH. While the men go about the serious business of fishing, a group of women and other family members enjoys a picnic on the beach at Robinson's Hole. Hats and long dresses are very much in order for such an outing and do not seem to have interfered with their ability to have a good time. (Courtesy Pasque Trustees.)

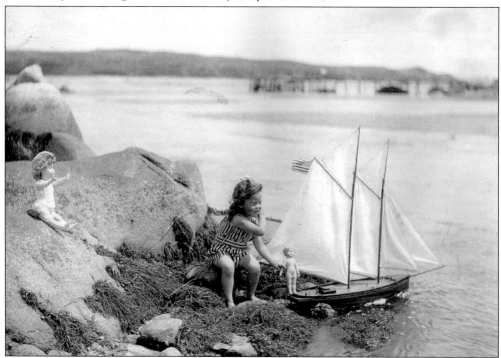

WHILE OTHERS FISHED. A charming little girl enjoys her time on the rocky shore, perhaps giving her dolls a sunbath and playing with the handsome model boat. (Courtesy Pasque Trustees.)

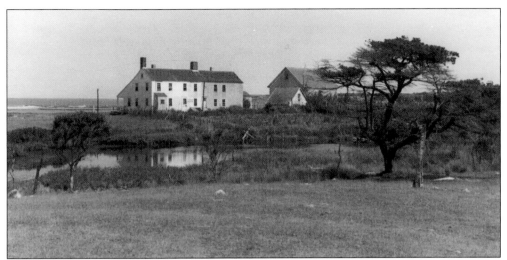

THE FARM BUILDINGS, SEPTEMBER 1948. The oldest part of the farmhouse on Nashawena is thought to have been built c. 1737. Soon after Edward and Waldo Forbes bought the island in 1905, further additions were made. Until recently, sheep have kept the island free of undergrowth, but because of coyotes, the herd has been greatly reduced and replaced with Scotch Highland cattle. (Courtesy Di Forbes Droste.)

EDWARD FORBES, 1873–1969. Together with his brother Waldo, Edward Forbes purchased Nashawena in 1905. He was a graduate of Harvard and became the distinguished director of the Fogg Museum in Cambridge. Like many of the Forbes family, he enjoyed painting, but music was also of great importance to him. Many family members recall his encouraging their own musical efforts. (Photograph by Celia Hubbard; courtesy Forbes family.)

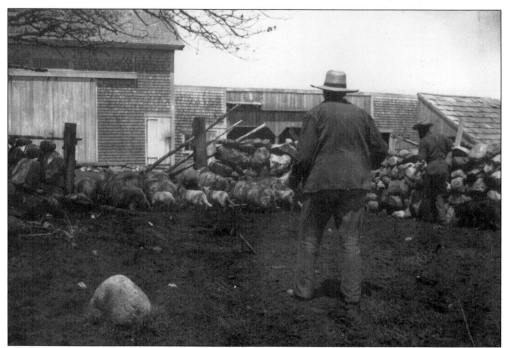

NASHAWENA SHEEP, 1901. Sheep were always part of the Nashawena scene. They kept the brush down and brought in a little income from wool or lamb. Driving them from around the island into the farm pens for shearing or separating twice a year was an important way of getting the family together for a useful cause.

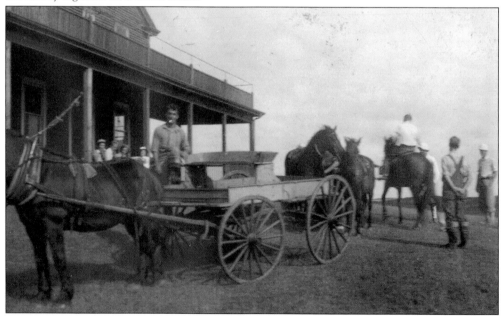

PREPARING FOR A SHEEP DRIVE, 1940. Organizing a sheep drive with riders and people on foot was a major operation, as from 30 to 40 people might be involved. This regular event took at least two days because the sheep were scattered all over the island and were wild and fast-moving. (Courtesy Di Forbes Droste.)

PENNED AFTER SHEARING, 1938. The sheep pictured here appear to have already been sheared. They would later be released to graze on the island. During the winter, they could shelter in sheds set up around Nashawena. (Courtesy Di Forbes Droste.)

A HAY WAGON WITH OXEN, 1920S. The driver, Frank Vincent, was the caretaker-farmer at Nashawena when the Forbes ownership began. He had previously worked for the Merrills, the former owners. The two boys are Stephen and Waldo Forbes, children of Waldo Forbes. (Courtesy Di Forbes Droste.)

BIBLIOGRAPHY

Bosworth, Janet, ed. *Cuttyhunk and the Elizabeth Islands from 1602*. Cuttyhunk Historical Society, 1993.

Bosworth, Janet, ed. "Three Town Buildings: the School, the Library, the Town Hall; and the Church, the Store, the Post Office." Monograph. July 1985.

Brewer, Margaret. *Cuttyhunk As I Remember It (in 1904)*. Cuttyhunk Historical Center, 1979.

Buckley, I. Thomas. *Penikese Island of Hope*. Privately printed, 1997.

Clark, Admont G. "The Tarpaulin Cove Lighthouse." Monograph. Cuttyhunk Historical Society, spring 2001.

Cuttyhunk Historical Society. "A Letter from Tim Akin." *Quarterboard*, spring 2001.

Cuttyhunk Historical Society. *People of Cuttyhunk*. 1986.

Cuttyhunk Historical Society. *People of Cuttyhunk II*. 1988.

Dexter, Lincoln A., ed. *The Gosnold Discoveries in the North Part of Virginia, 1602*. Universal Tag Inc., 1982.

"Early CYC History." *Cuttyhunk Yacht Club Newsletter*, spring 1988.

Forbes, Kathleen A. *An Anthology of Nashawena*. Privately printed, 1972.

Forbes, Kathleen A. *Naushon Anthology*. Privately printed, 1979.

Garfield, Wyatt. *Tales of Cuttyhunk: As Remembered by Wye Garfield*. Weezrock Publications, June 2000.

Hale, Thomas. "New York Harbor Car Floats and the Barges Beach." Monograph. December 1993.

Haskell, Louise T. *The Story of Cuttyhunk*. 1953.

Howland, Alice Forbes. *Three Islands: Pasque, Nashawena and Penikese*. Privately printed, 1964.

Reeves, Marjorie Snow. "Memories of Growing up on Cuttyhunk Island 1917–1925." Monograph. Cuttyhunk Historical Society, winter 2000.

Twichell, Ethel R. "Cuttyhunk during World War II." Monograph. Cuttyhunk Historical Society, January 1993.

Wilder, Alan. "A Town of Many Islands." *Vineyard Gazette*, July 30, 1999.

Wilder, Donald. "Progress." Monograph. Cuttyhunk Historical Society, spring 1996.